Santa Fe was founded by Spanish colonists in 1610 and is known today as the oldest state capitol city in America. The name means Holy Faith in Spanish. At 7,198 feet above sea level and with a population bordering on seventy thousand, the town boasts a world-class opera house, more art galleries than any city in America other than the Big Apple, and more writers than anyone has attempted to compute. I love it here and wish that at least some of its towers would either migrate underground or find appropriate satellites to make phone lines and electricity more discrete. These towers, however, make terrific material for creative captures on film.

The Towers Of Santa Fe

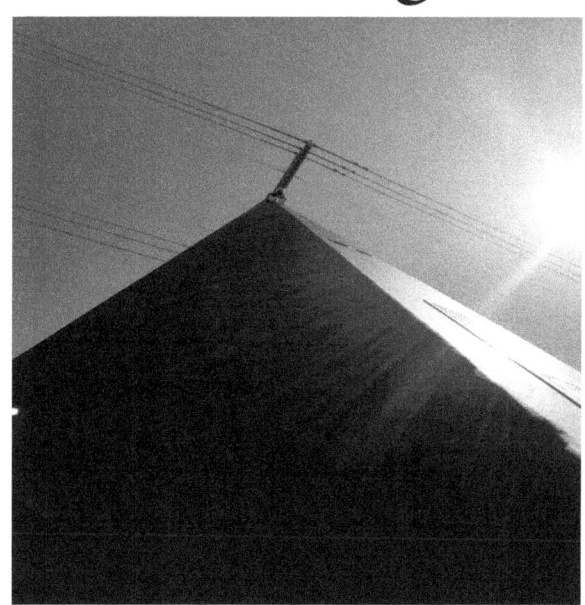

Photographs
By
David Cope

The Towers of Santa Fe
Photographs by David Cope

Epoc Books
Printed in the United States of America
© David Cope 2016
All Rights Reserved.
Published 2012.

The characters and events in this book are fictitious.
Any similarity to real persons, living or dead, is coincidental
and not intended by the author.

This book is dedicated to my wife, sons, and grandchildren, Zoe, Tess, Gavin, and Ethan whose excitement for everyday things never ceases to amaze me. And to those older kids like me who believe in those children.

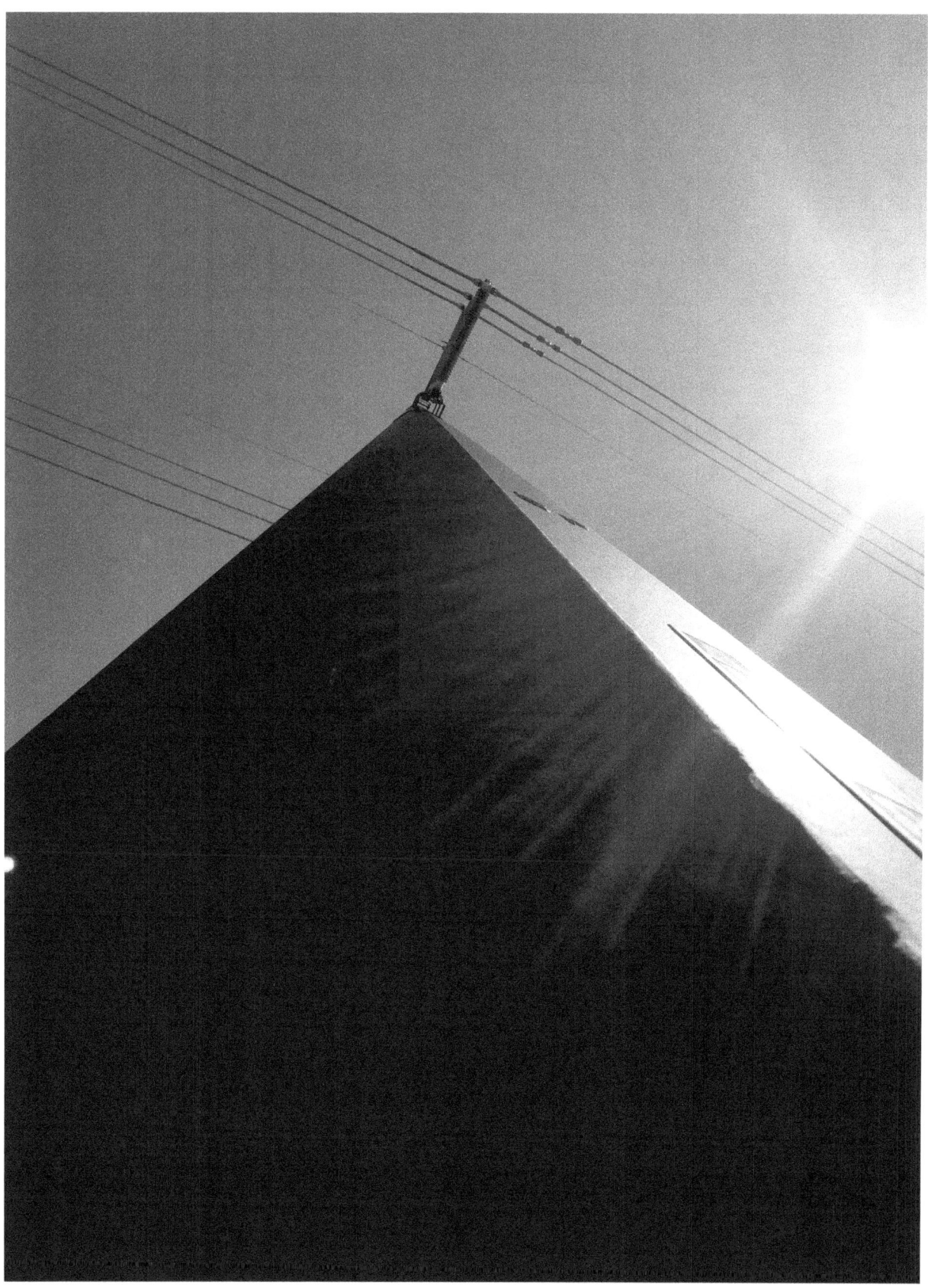

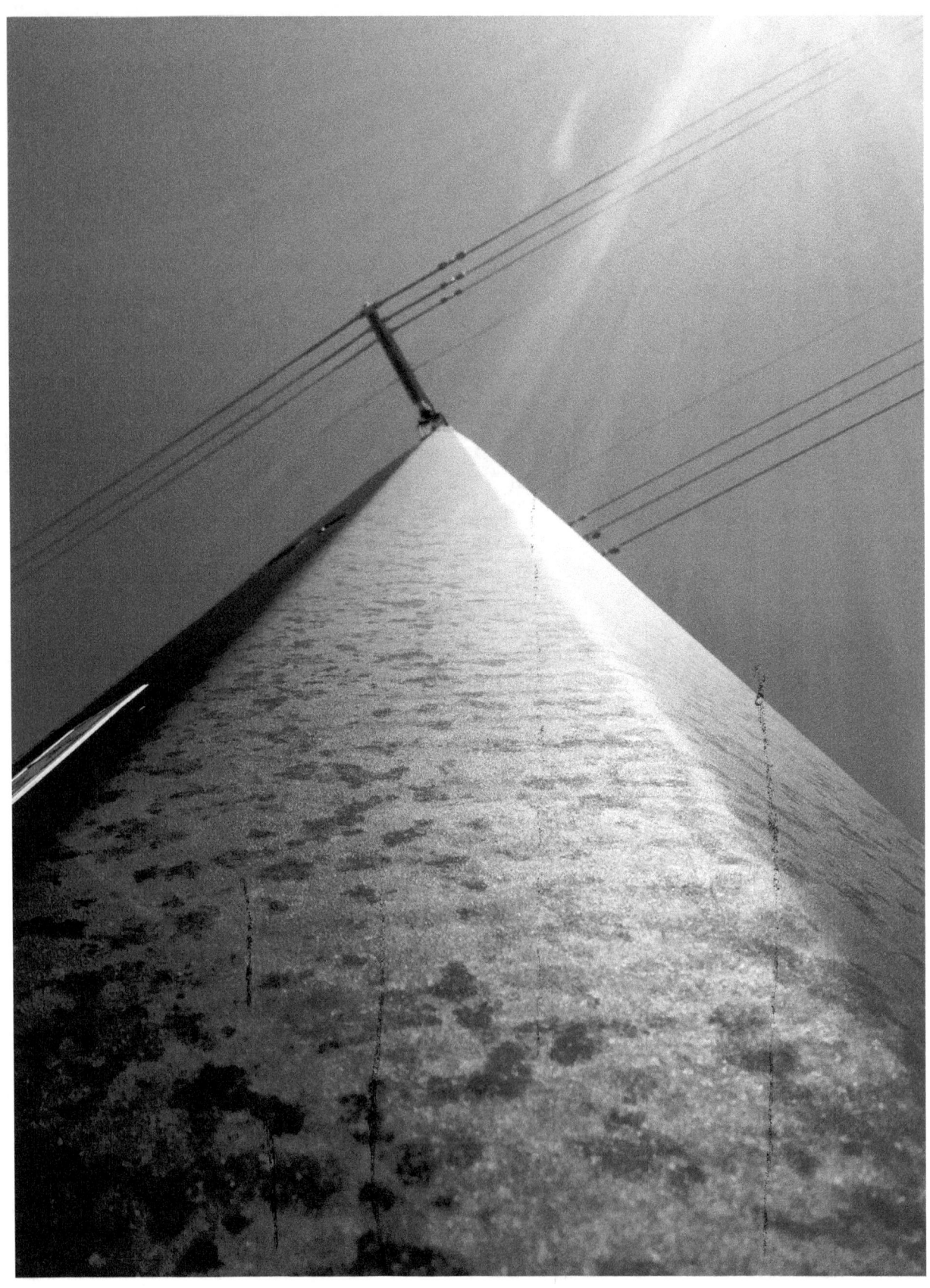

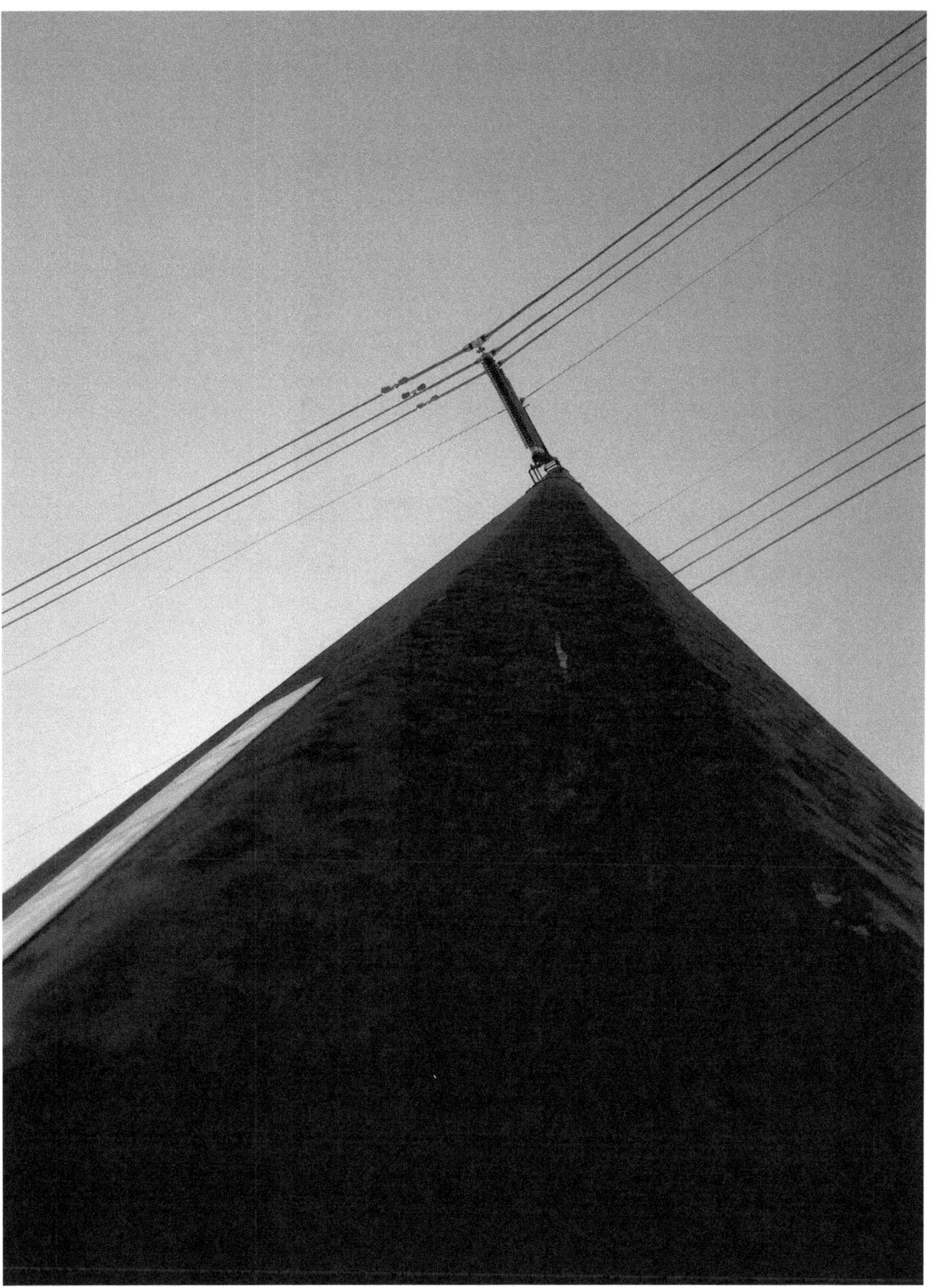

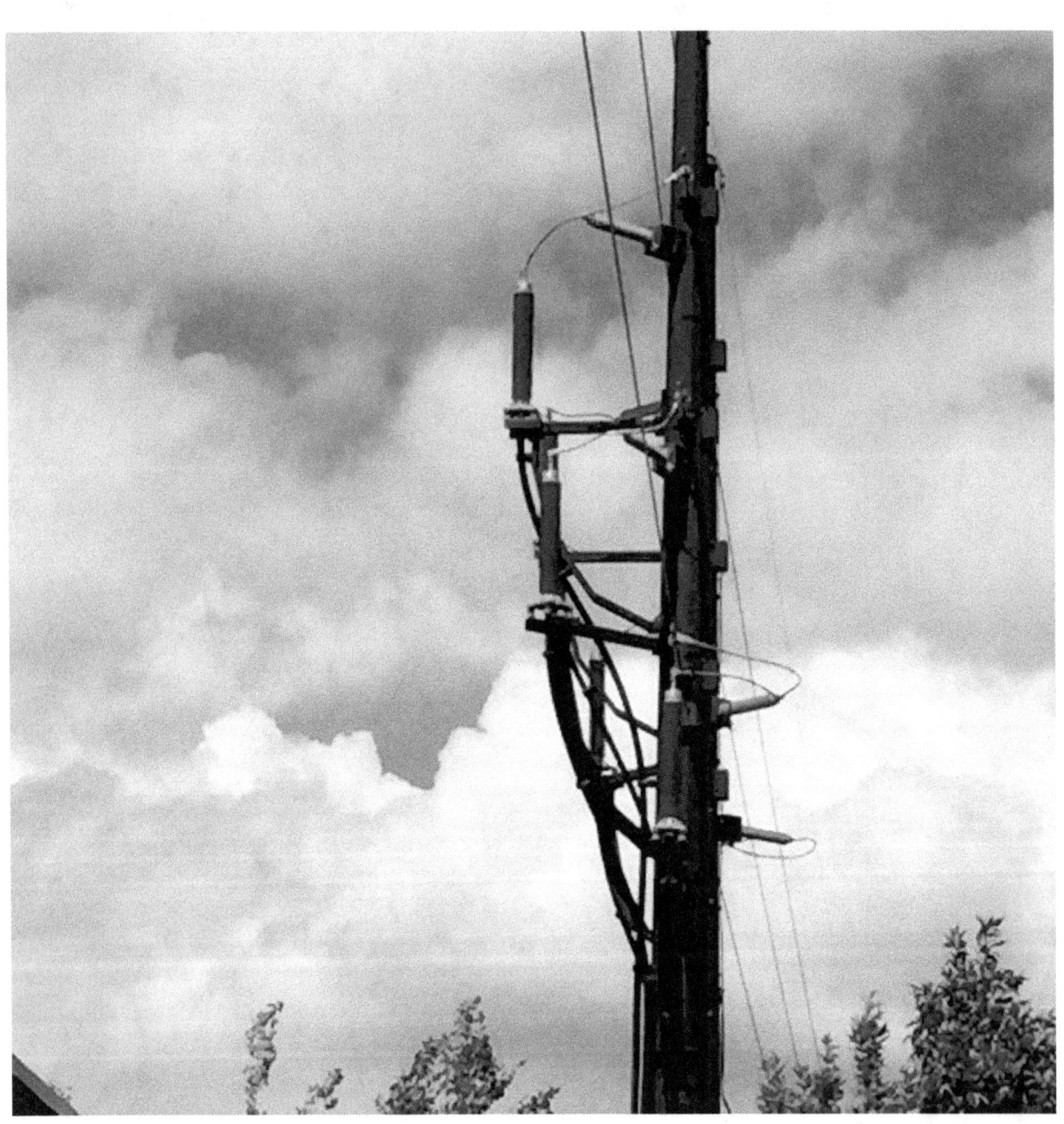

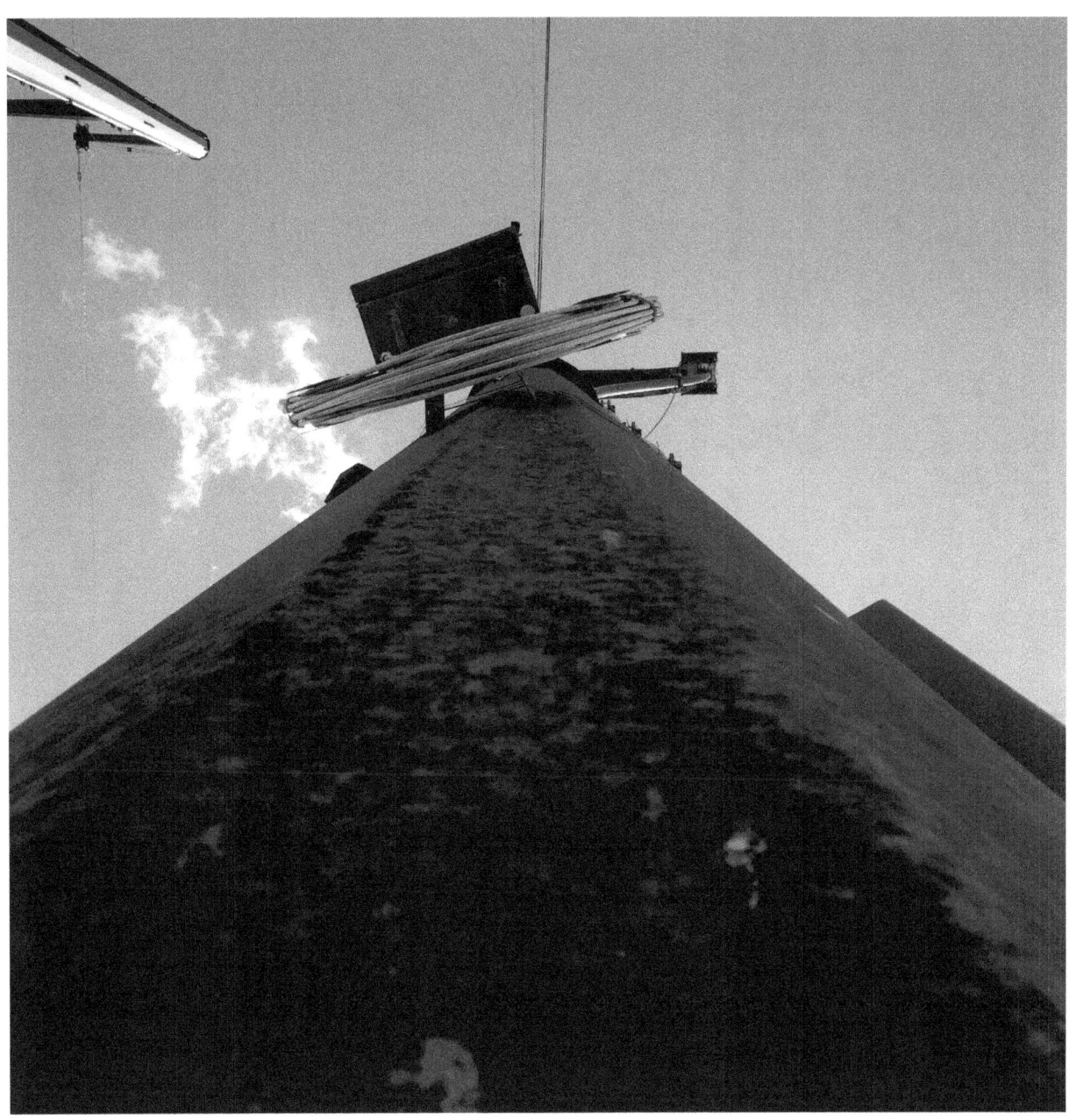

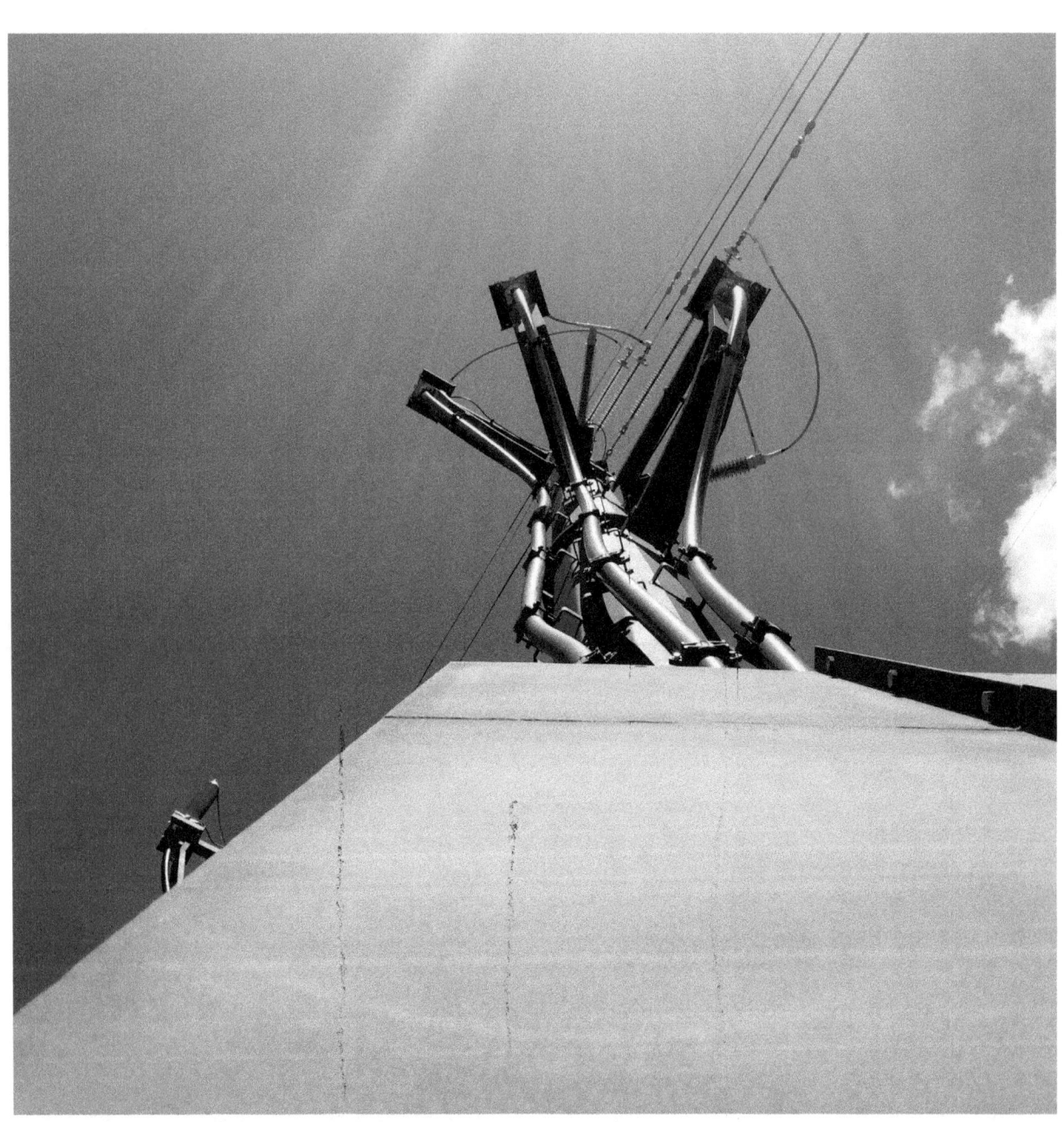

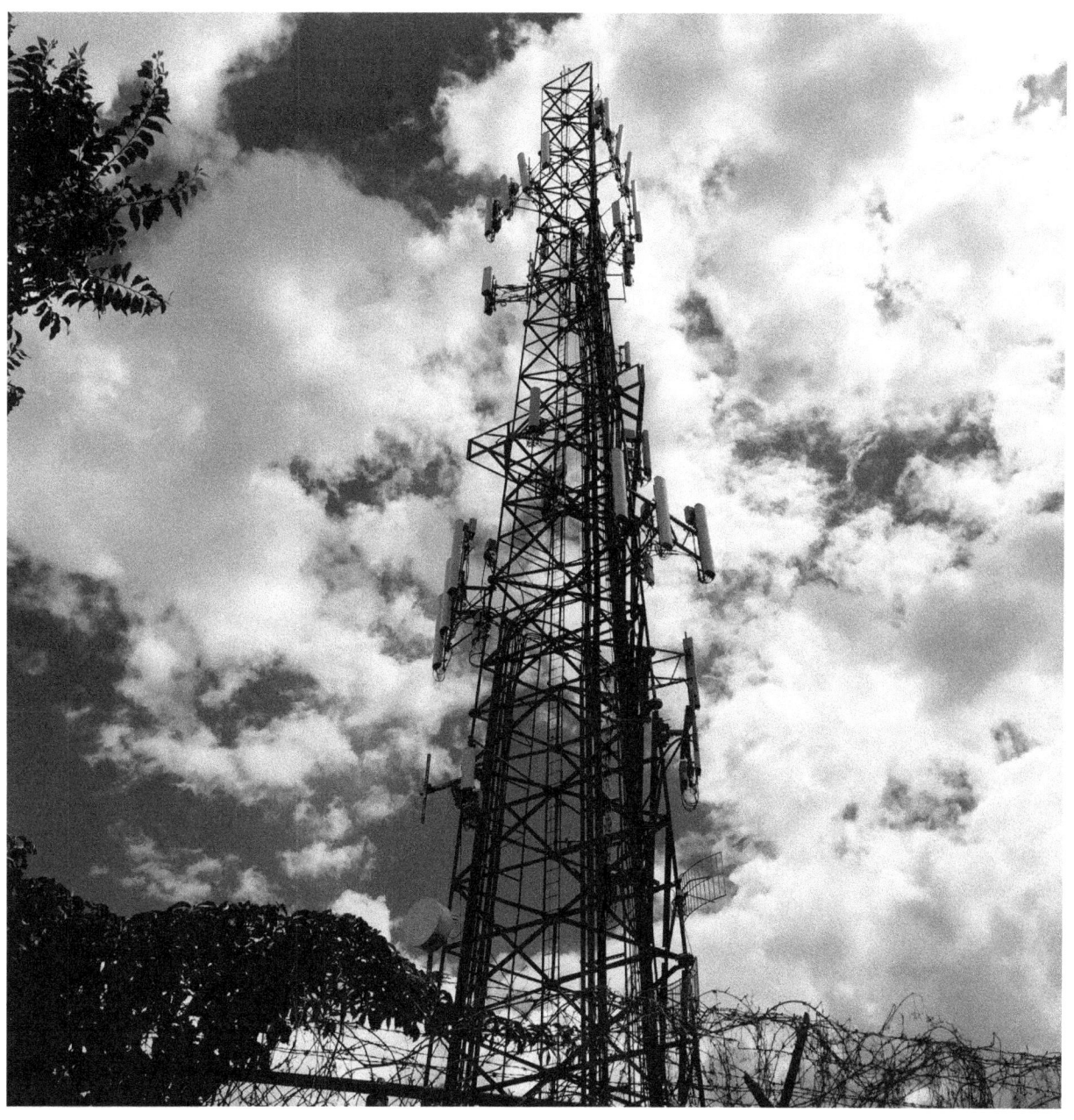

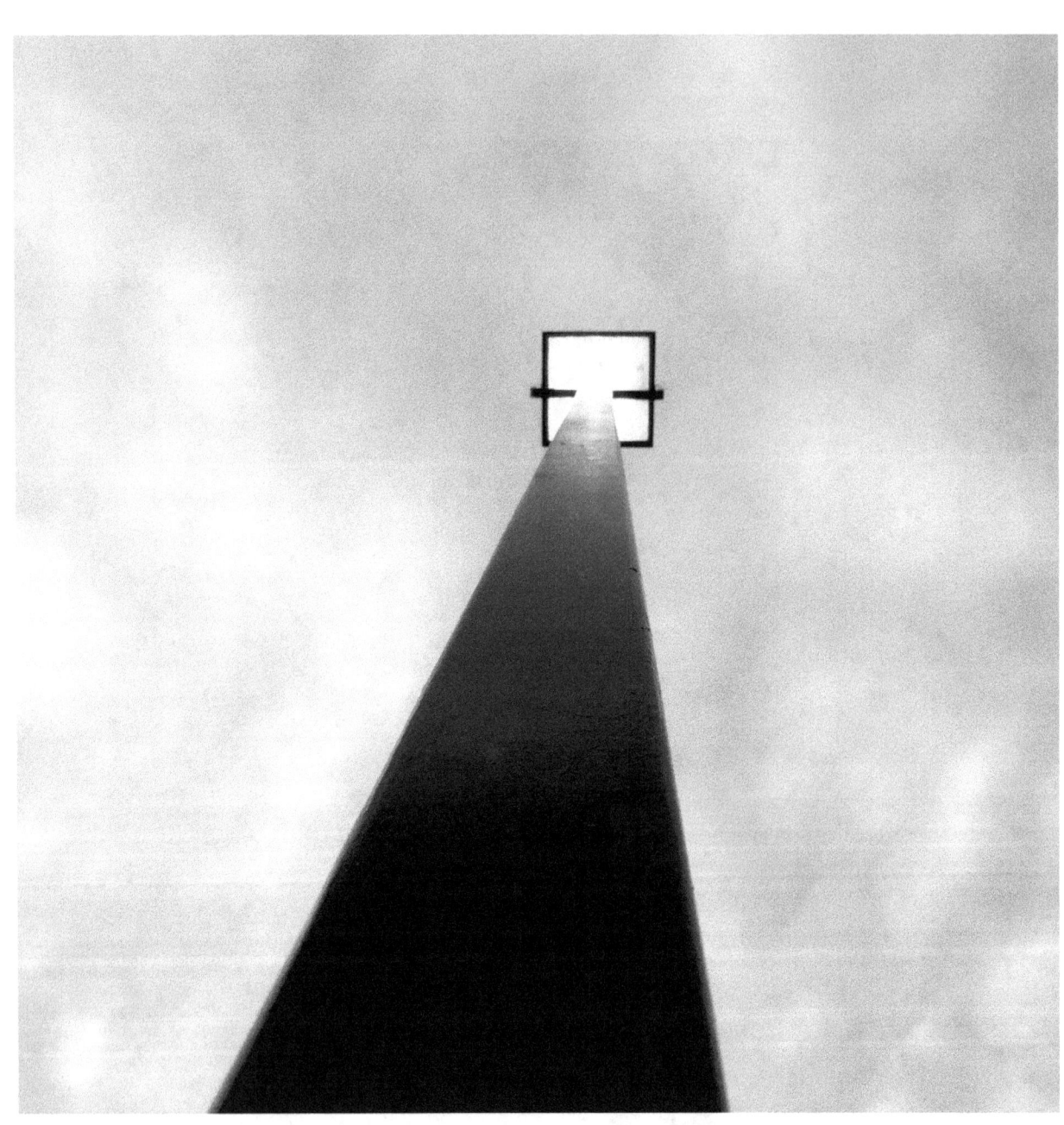

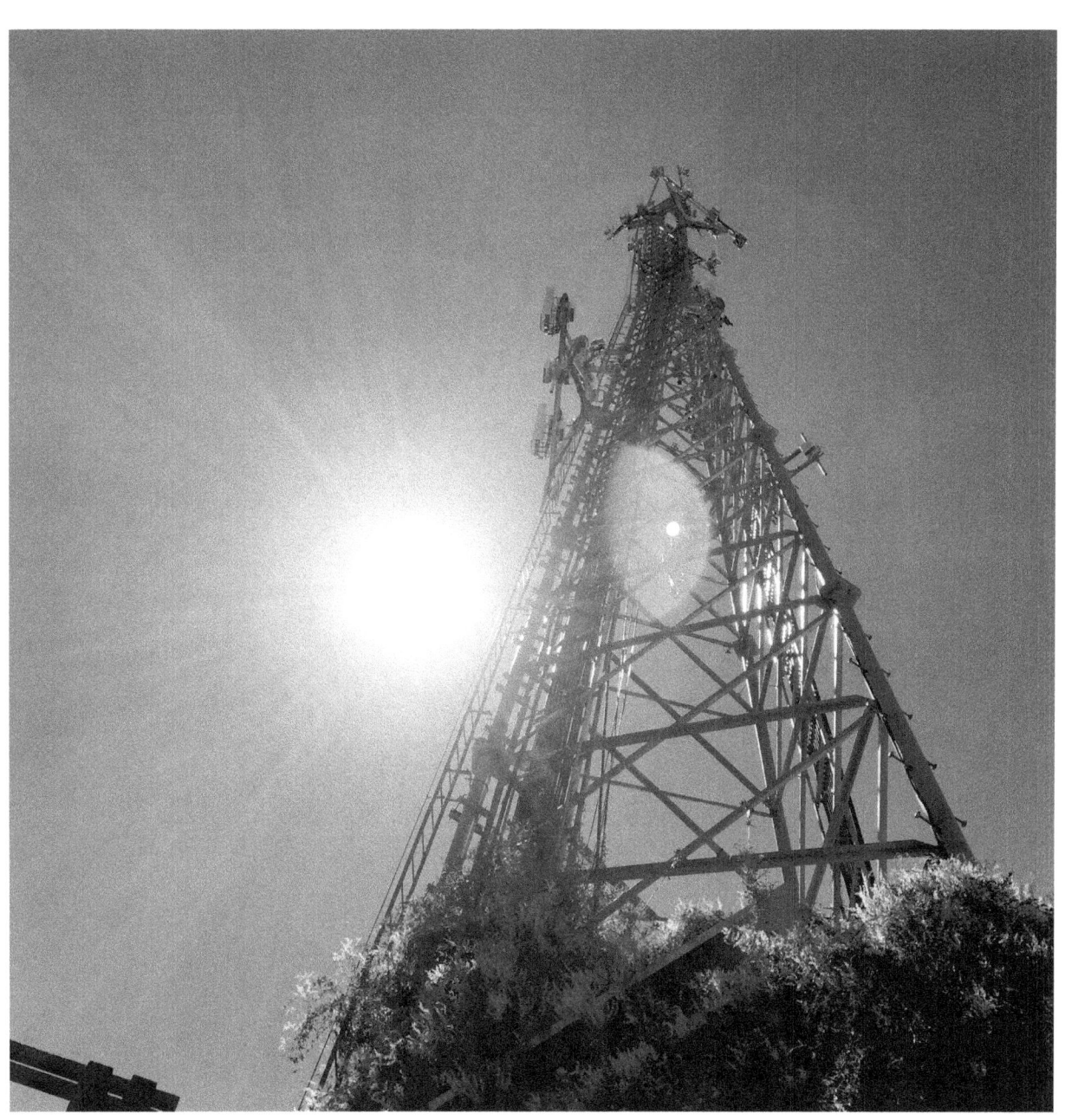

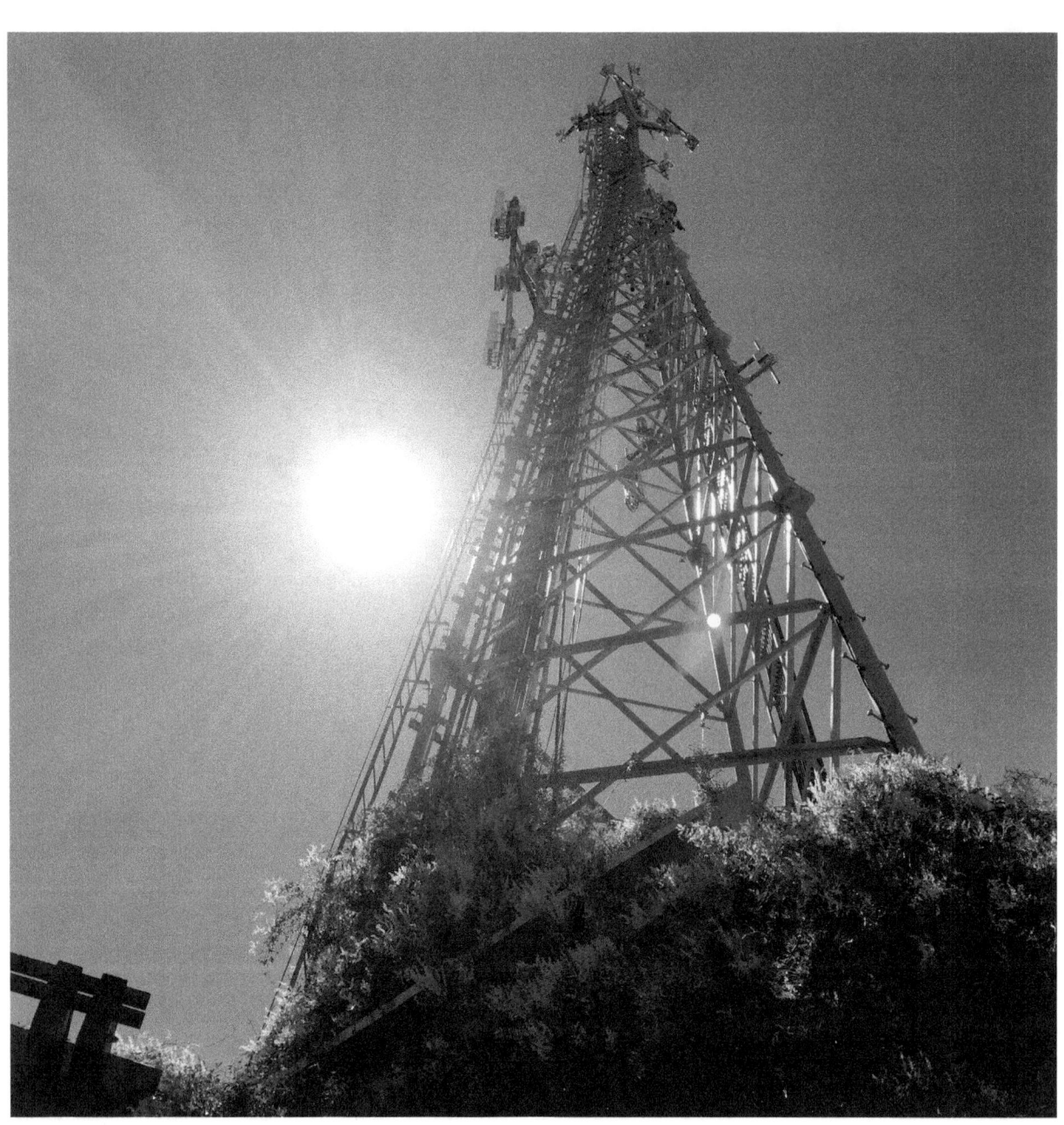

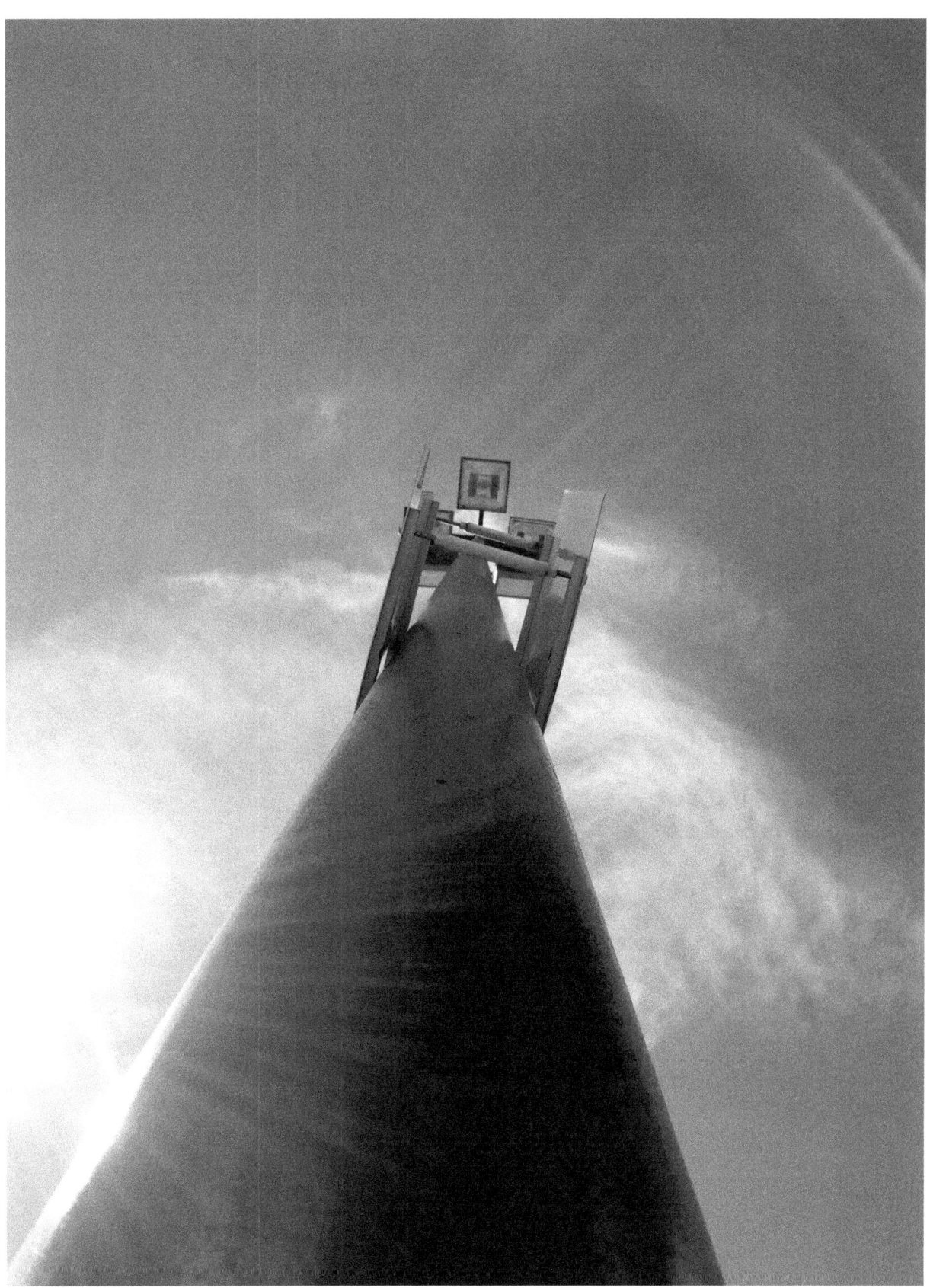

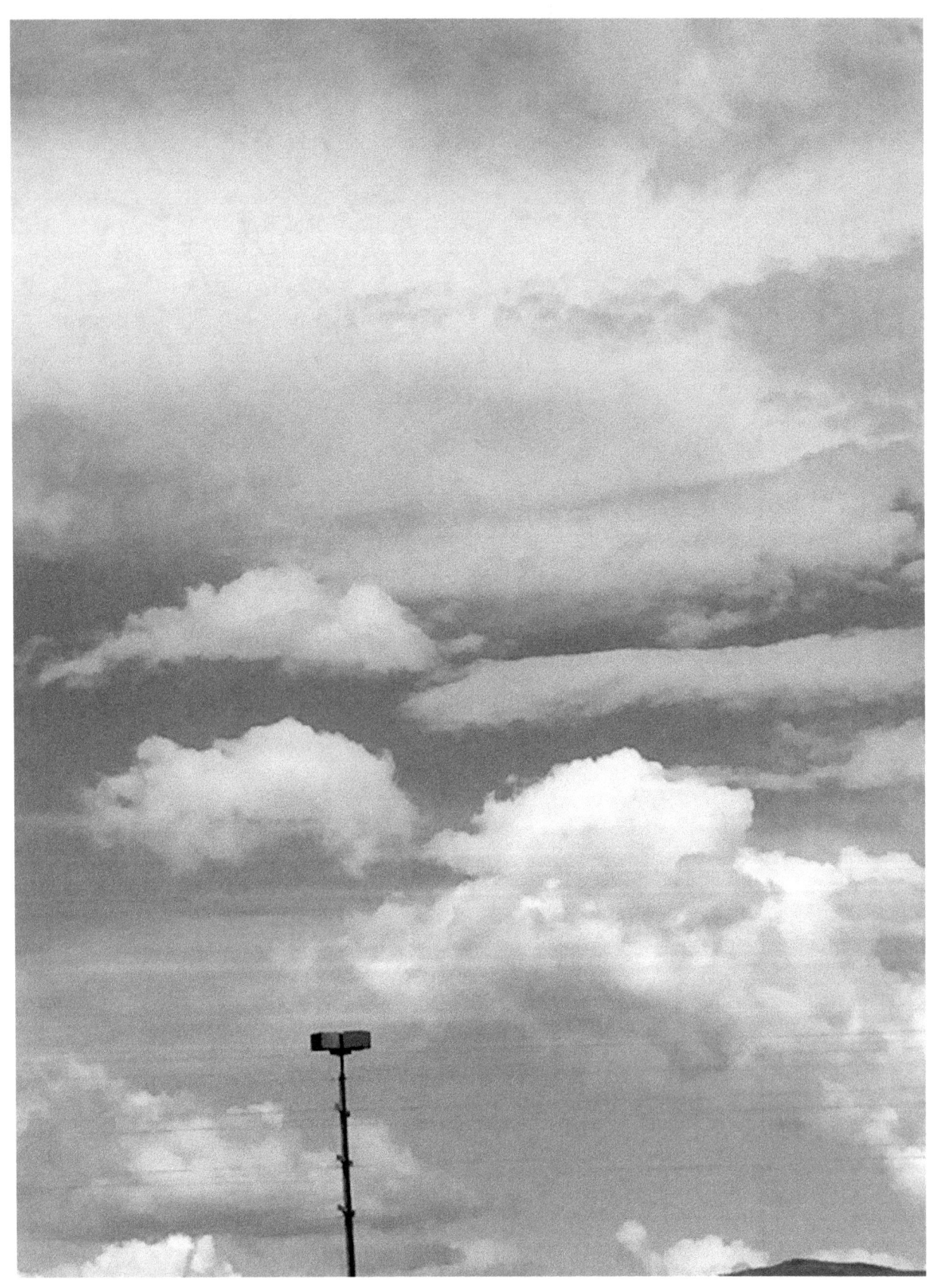

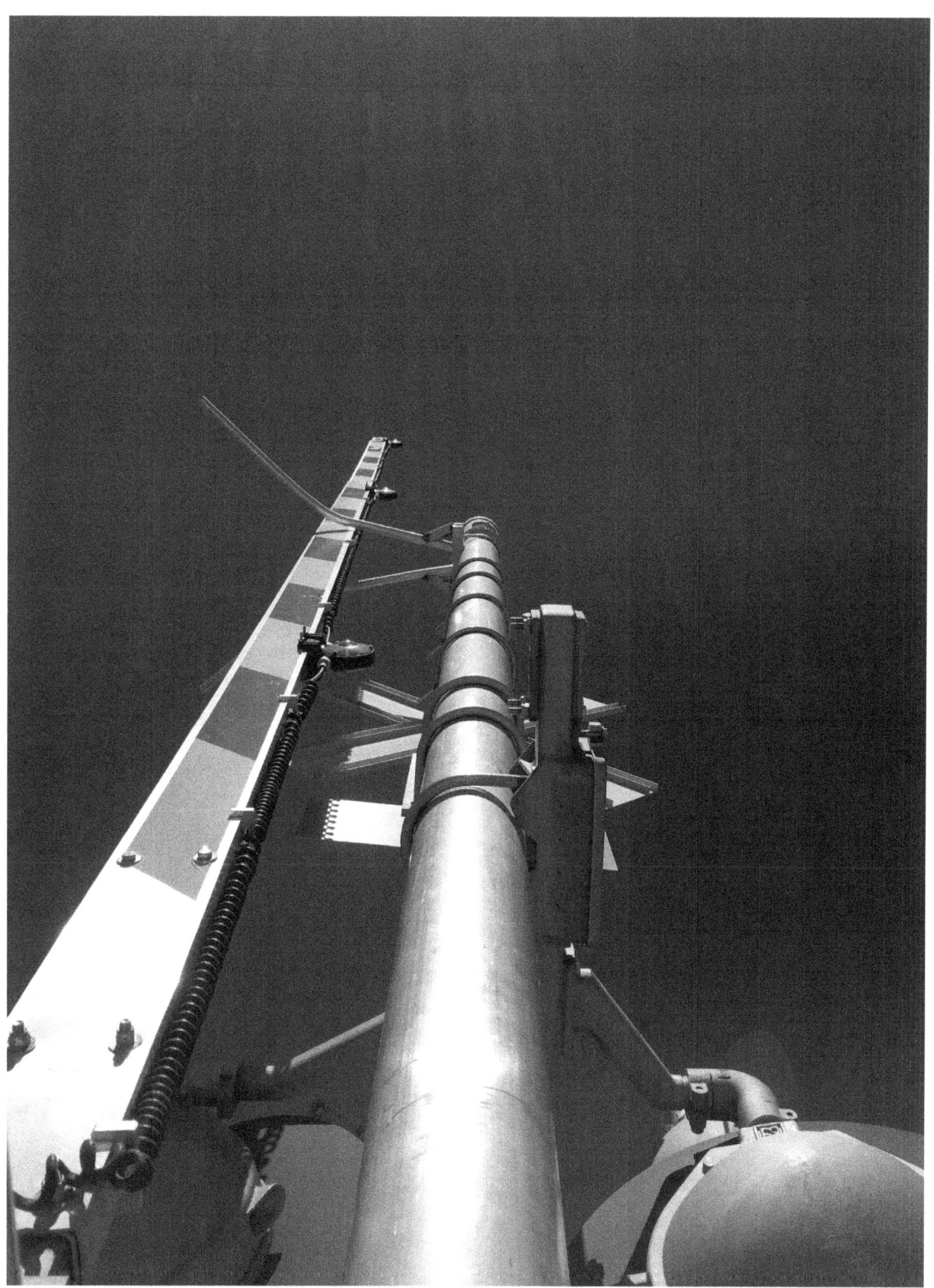

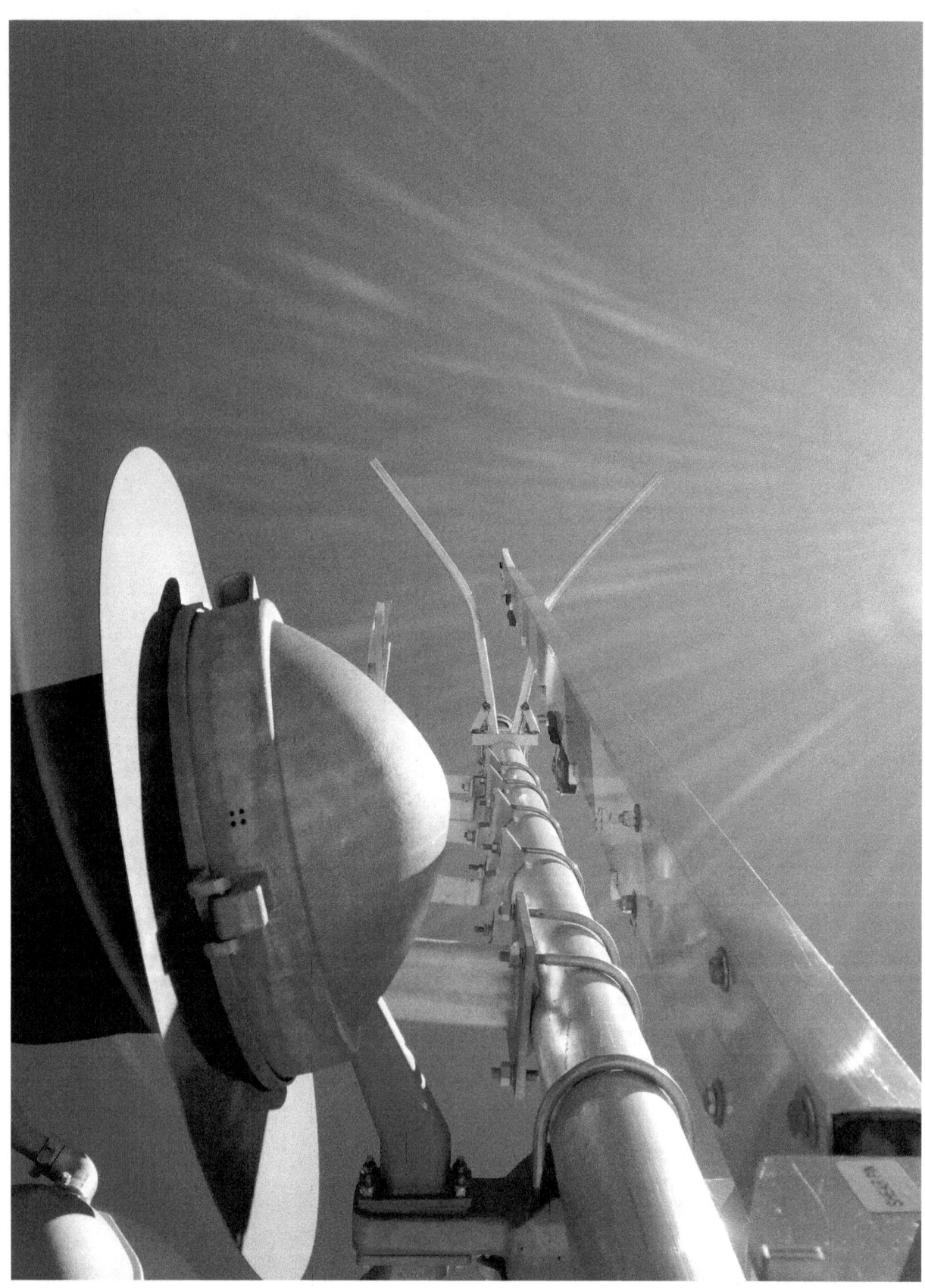

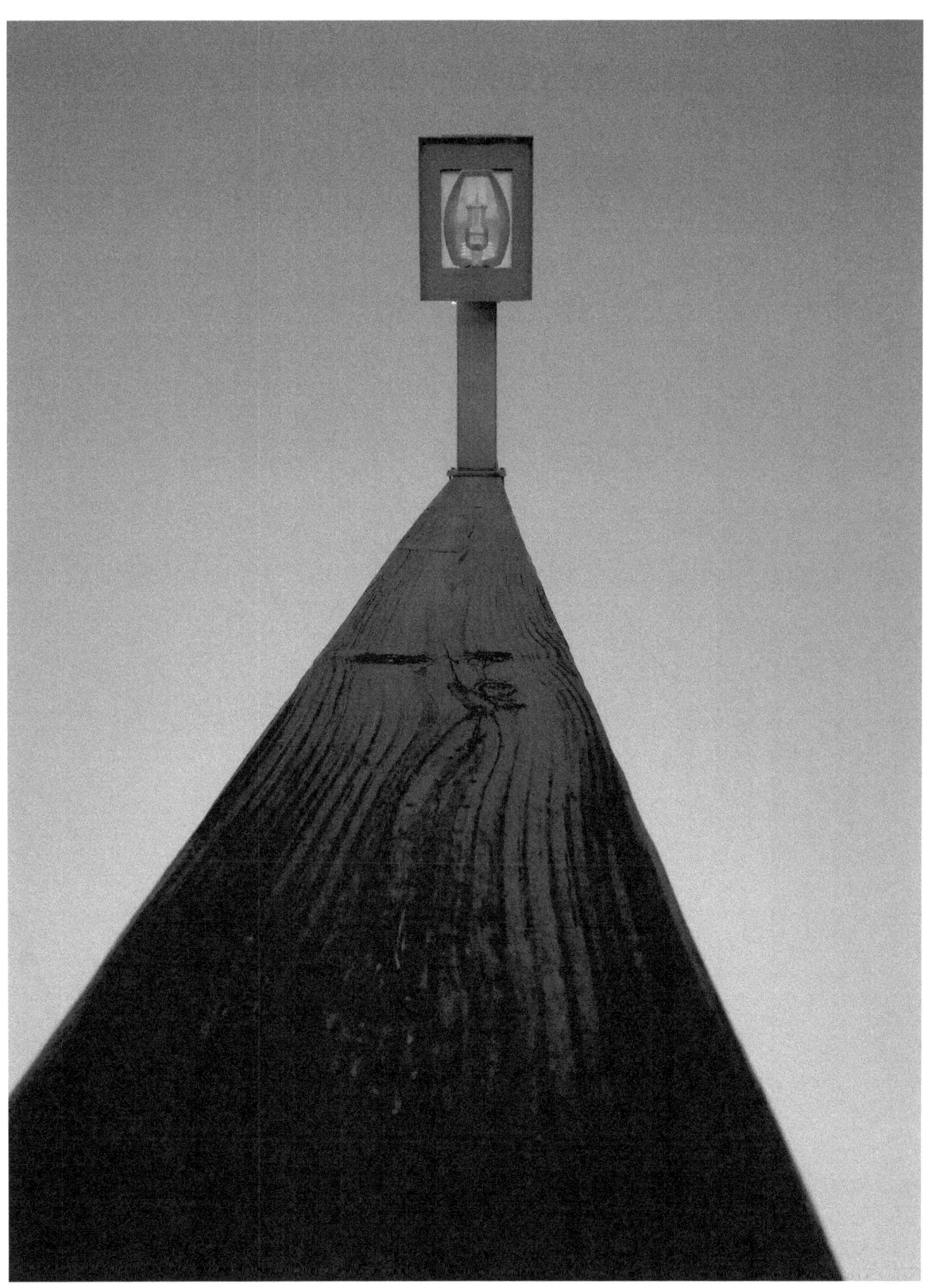

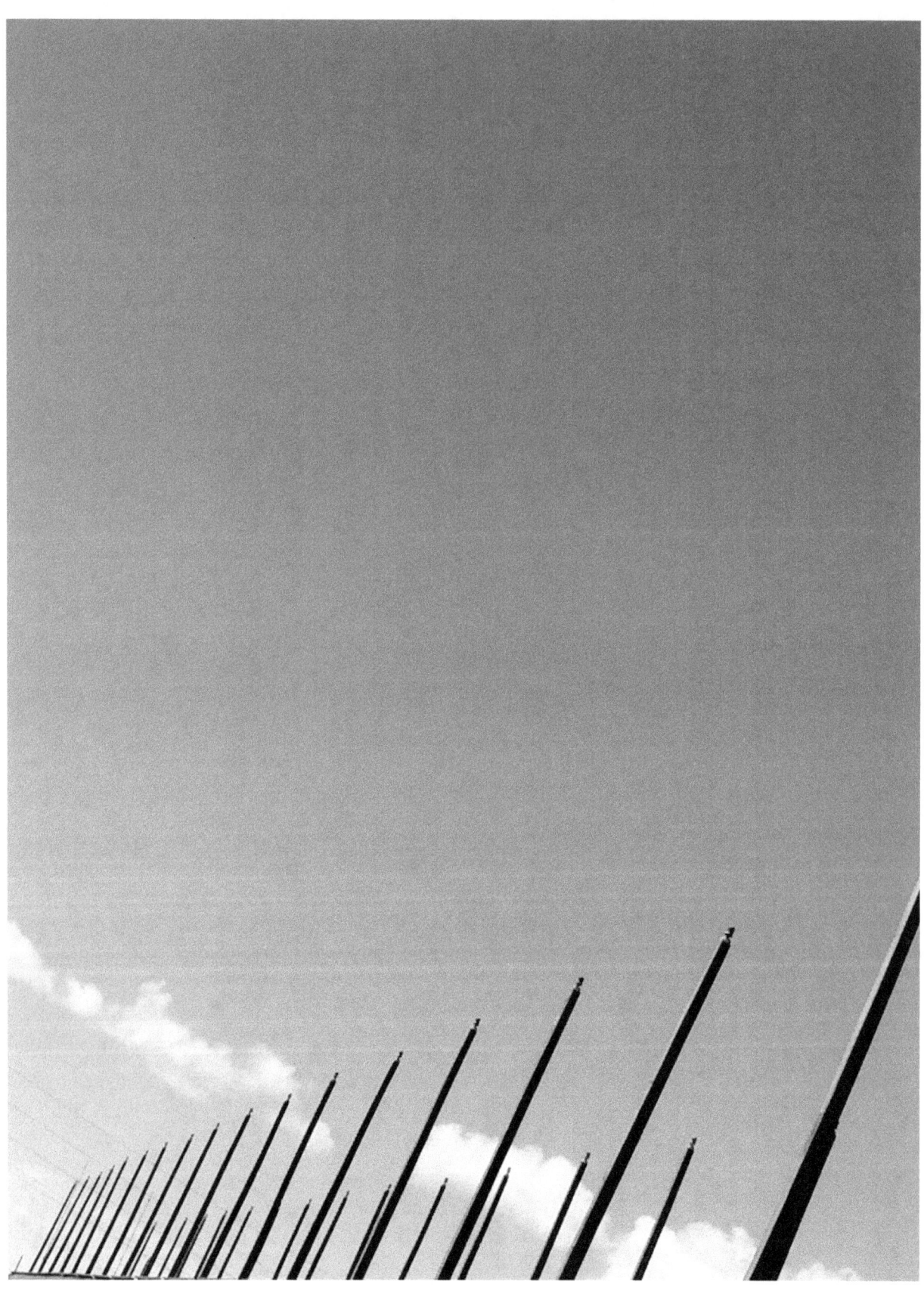

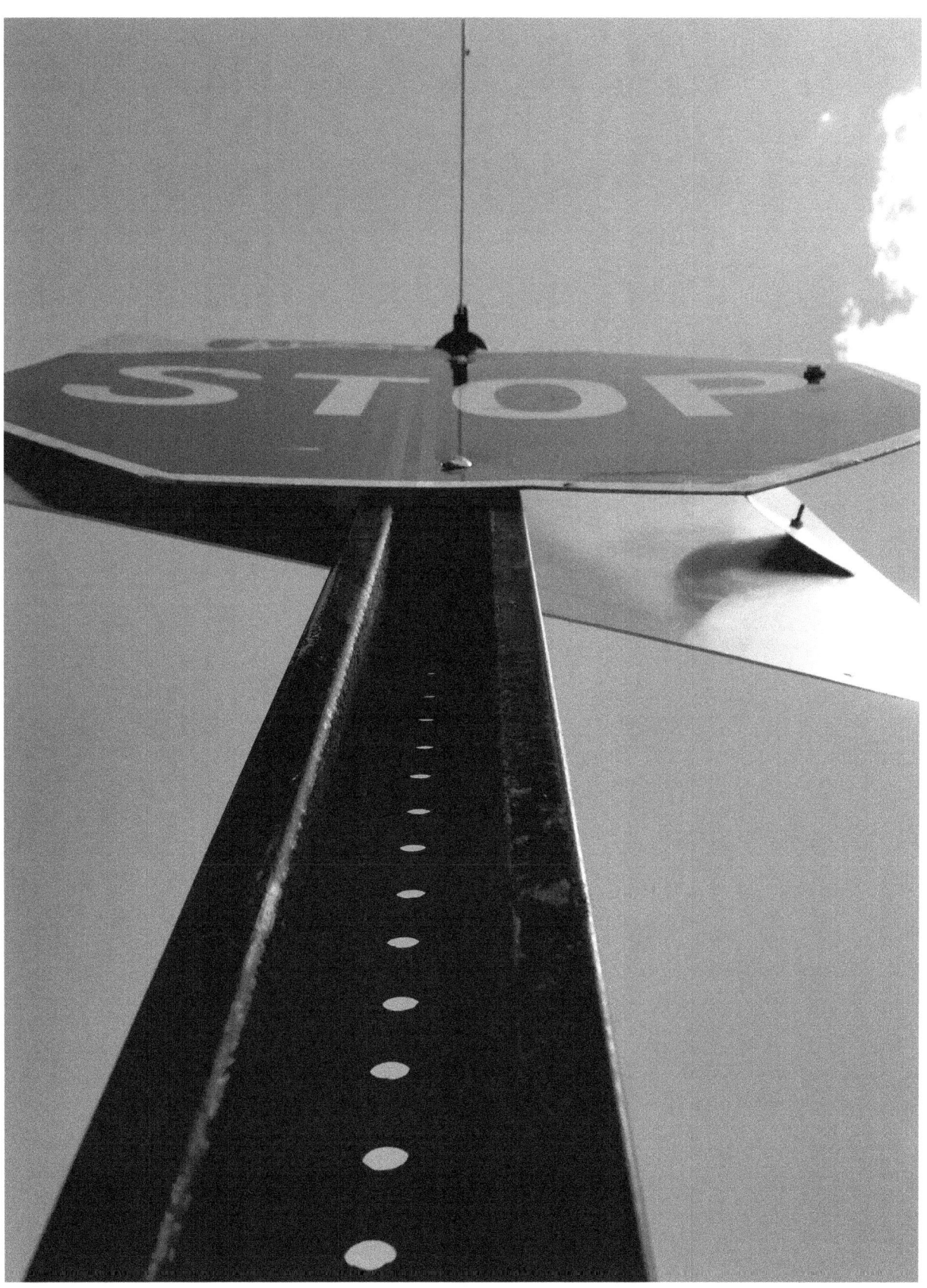

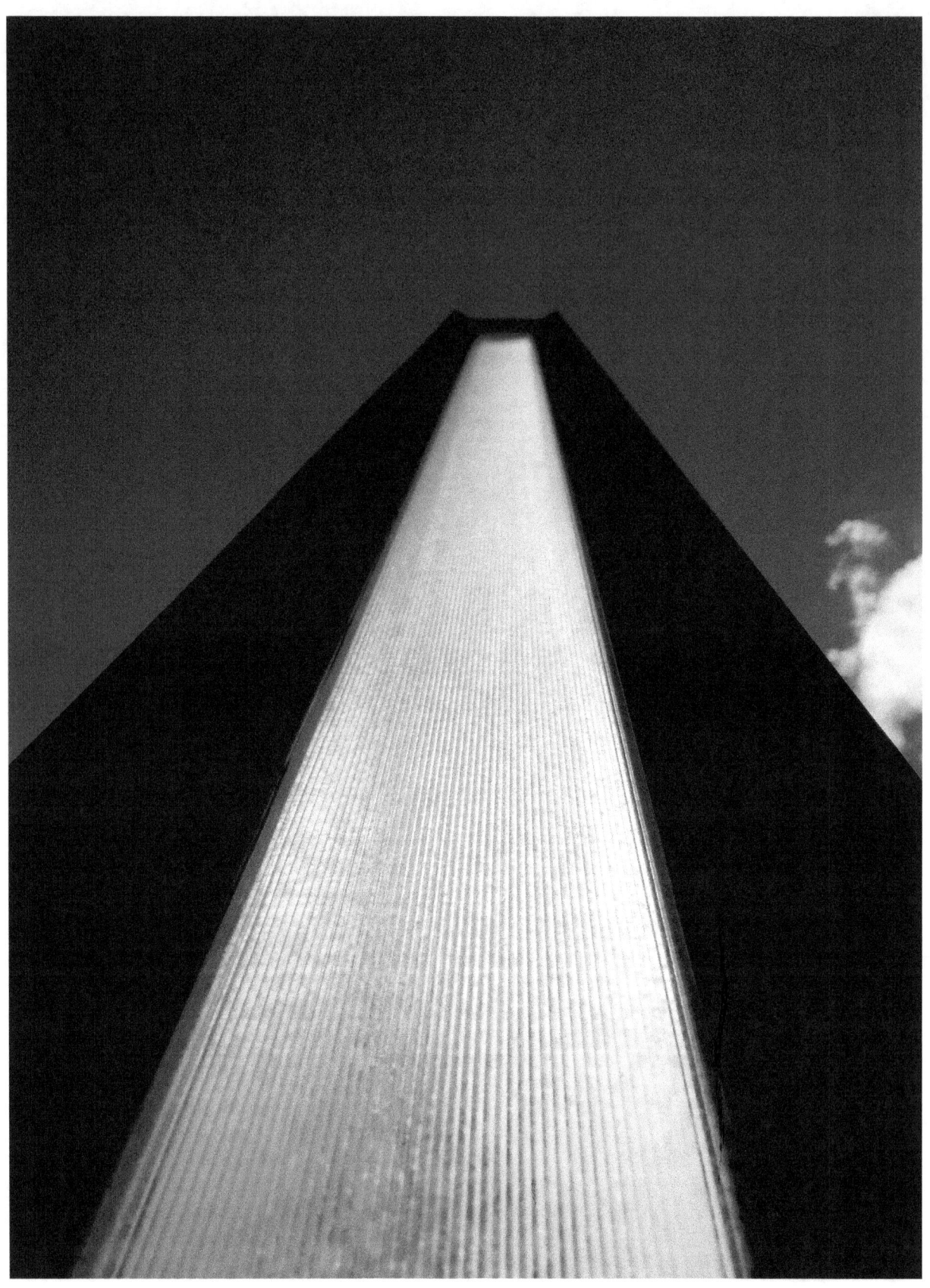

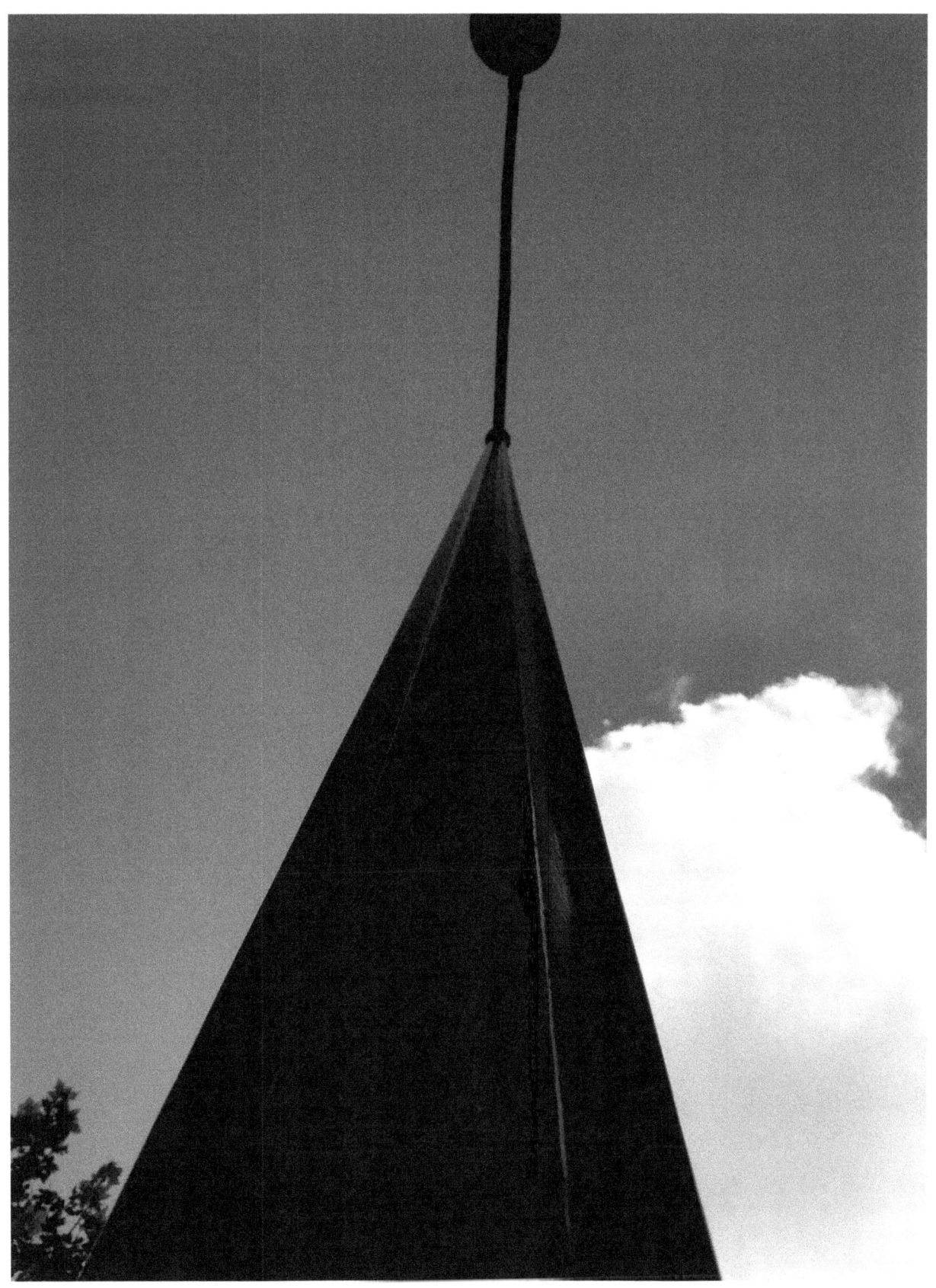

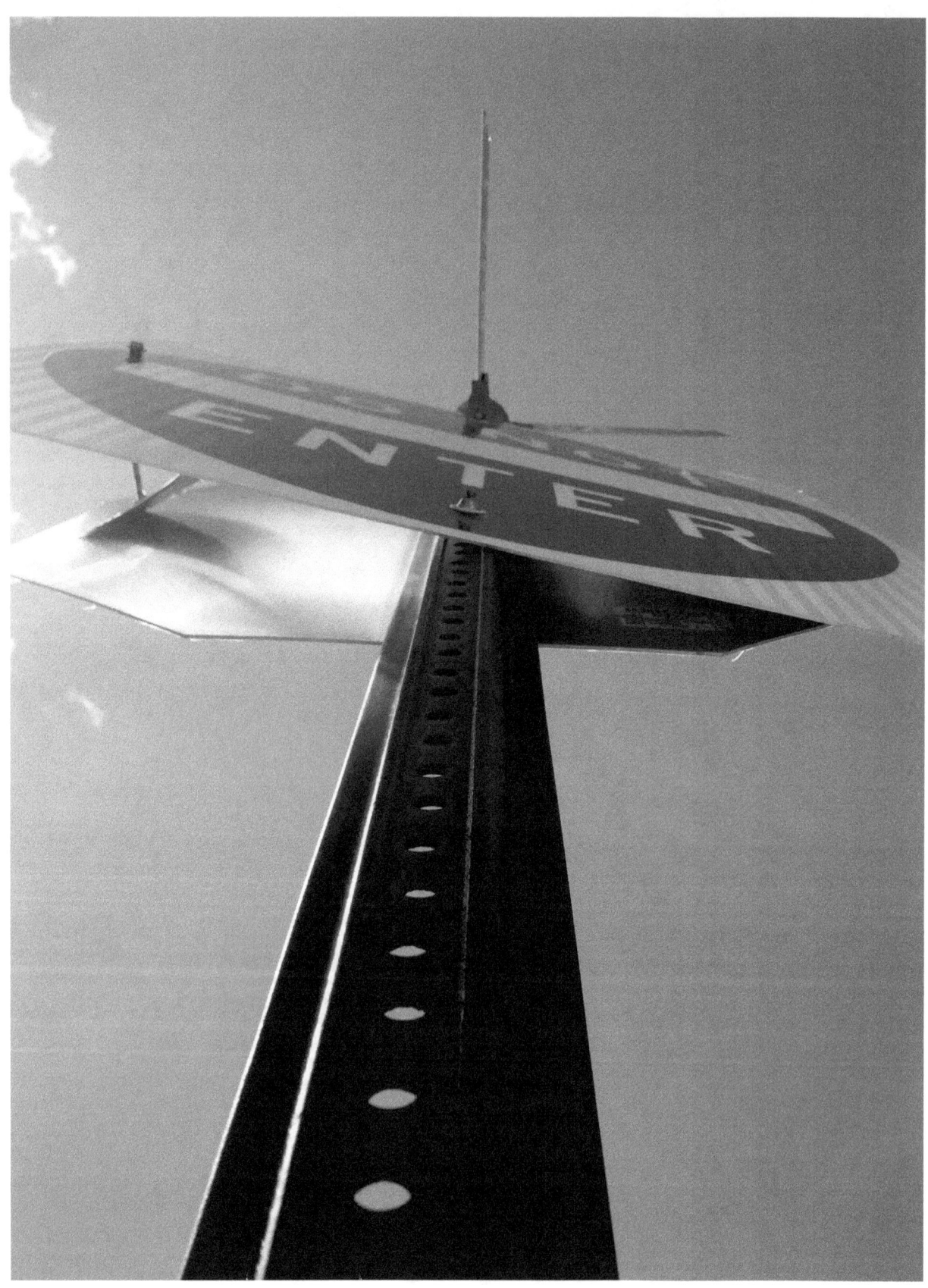

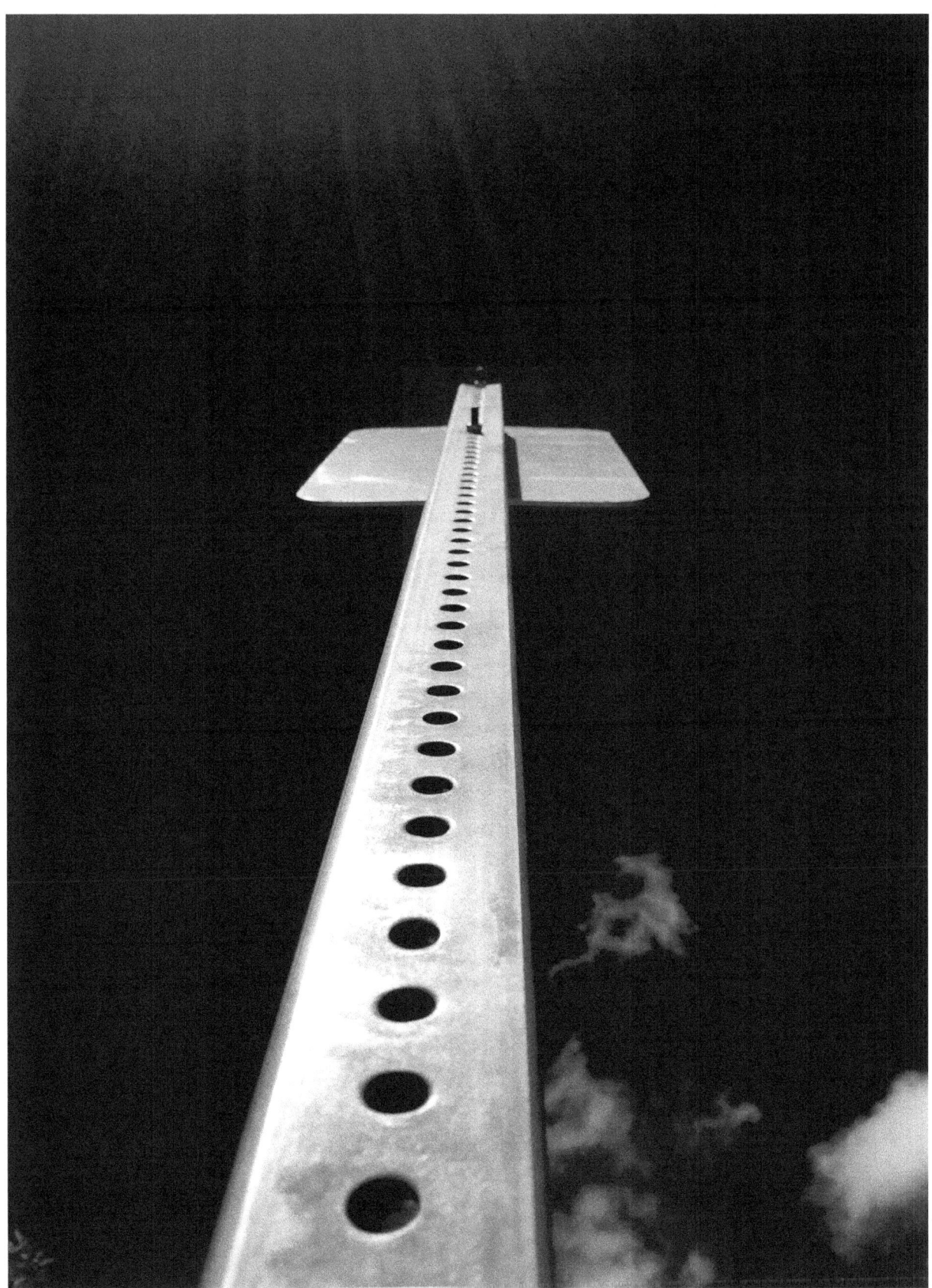

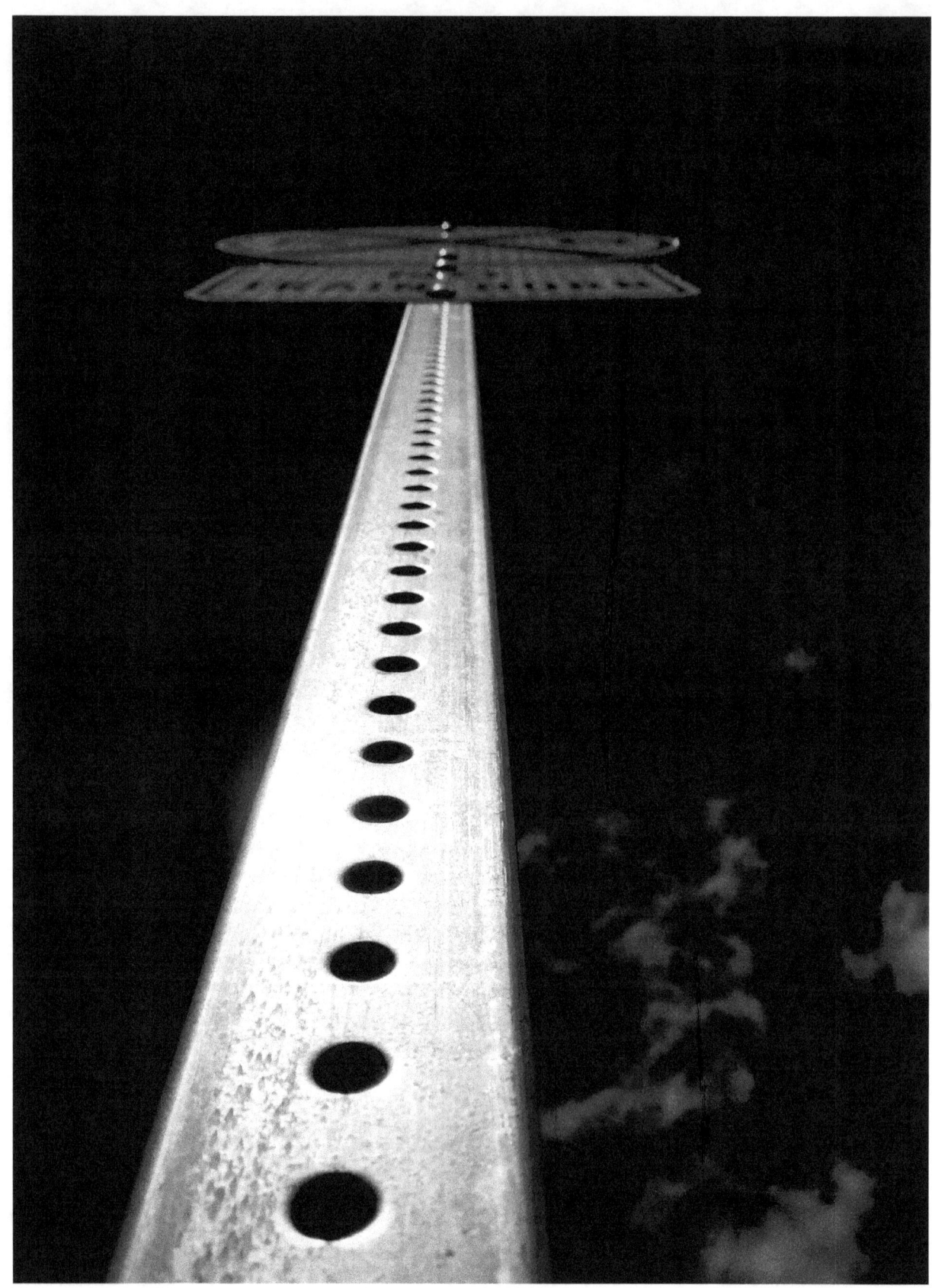

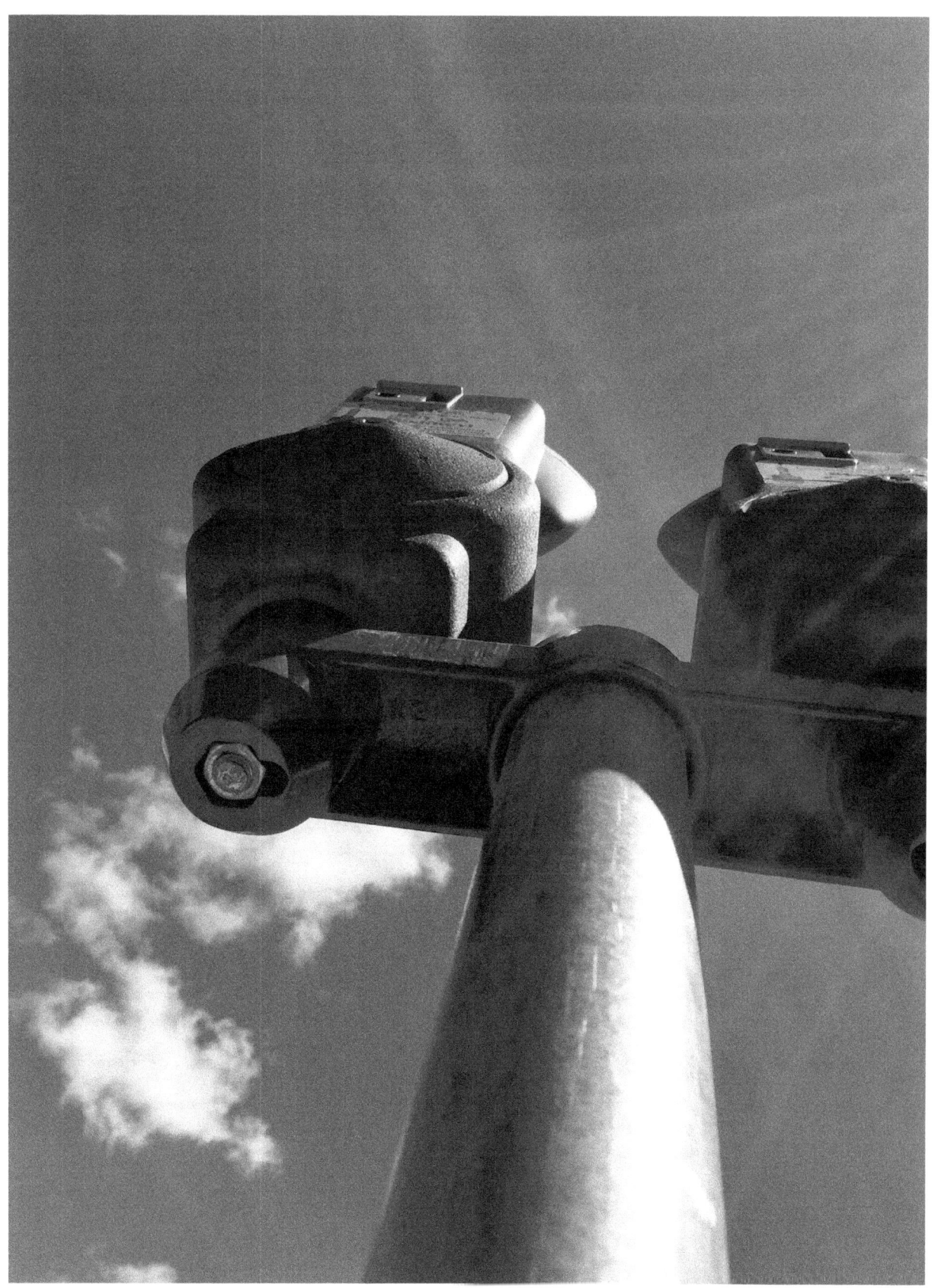

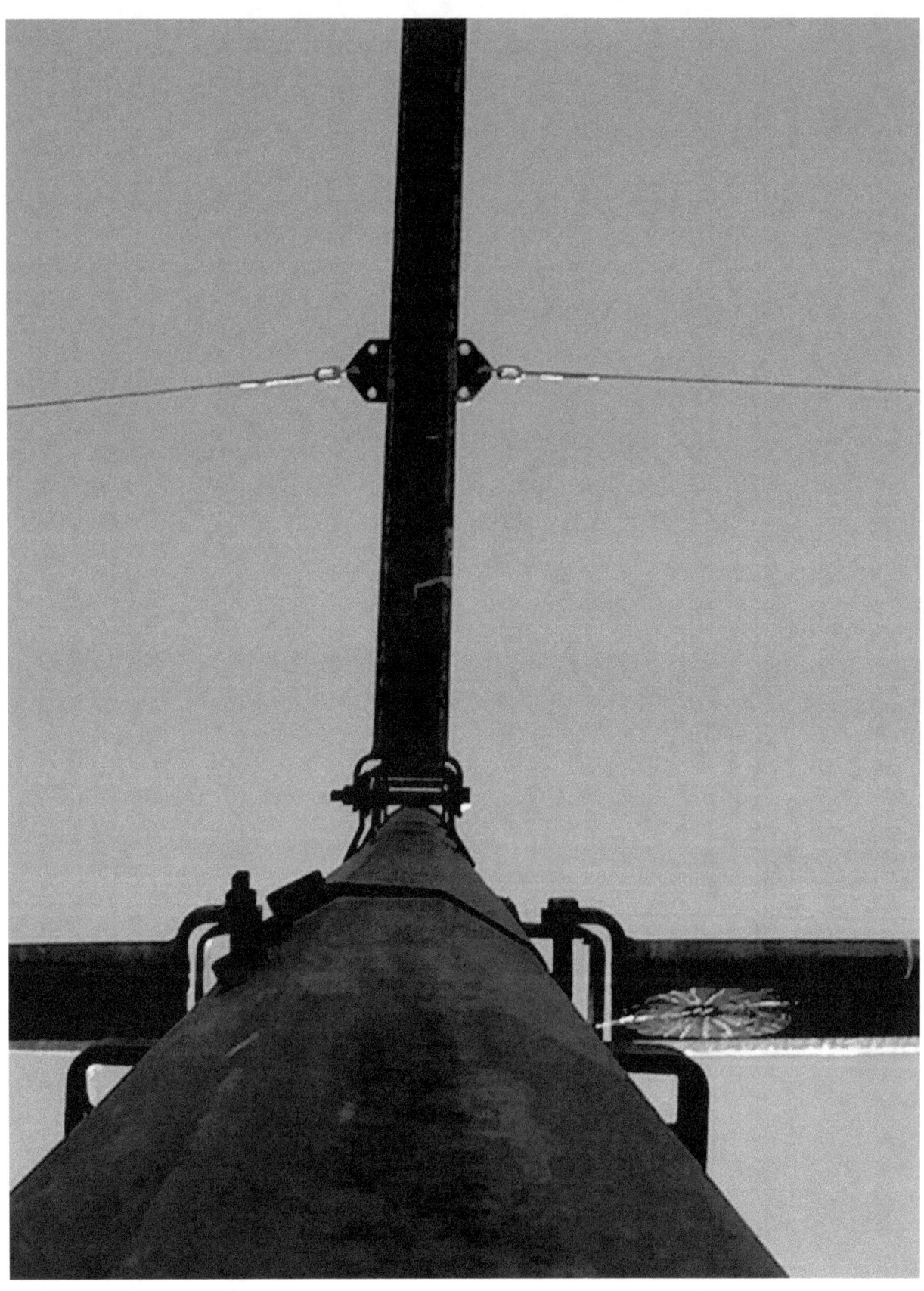

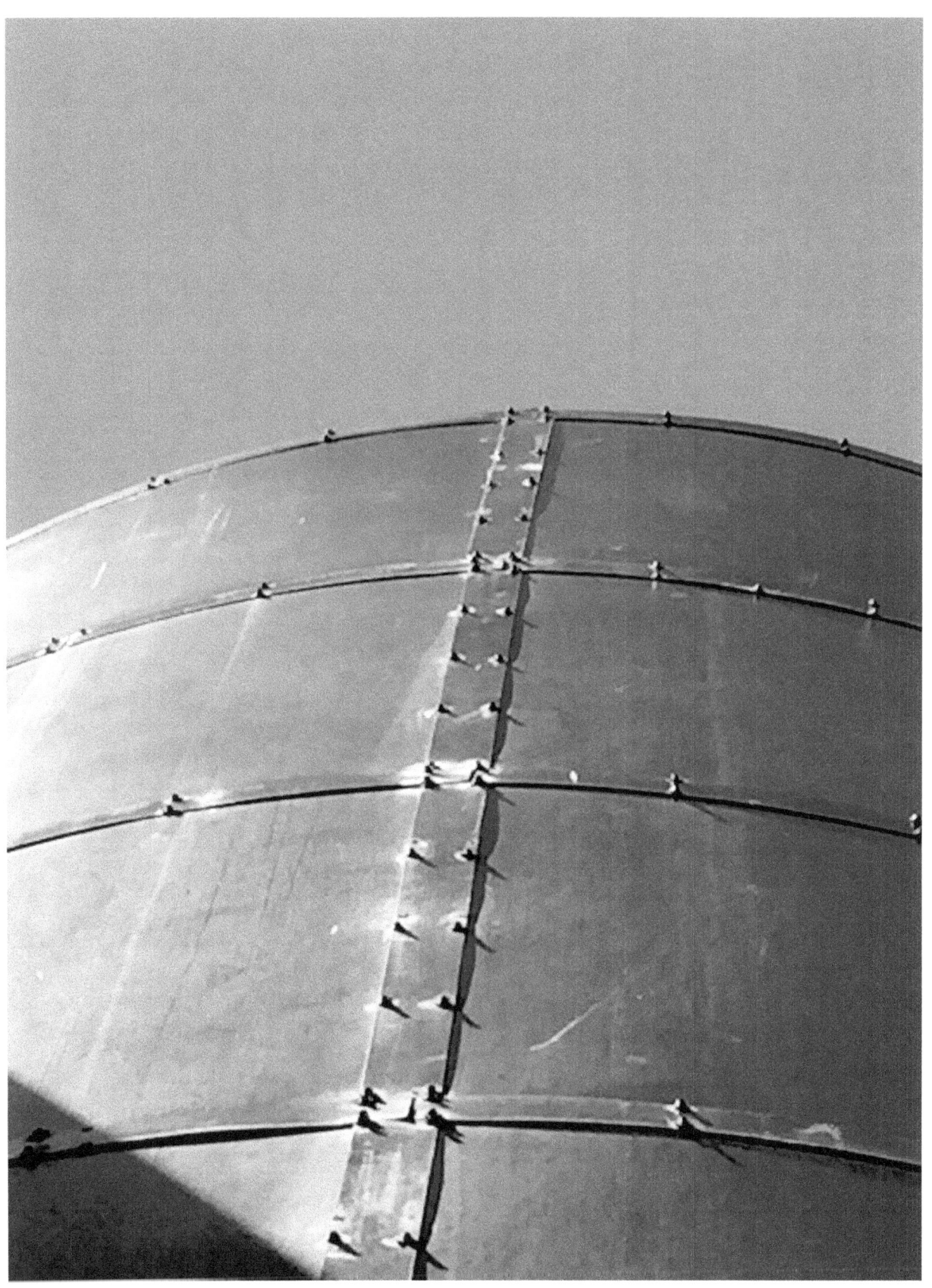

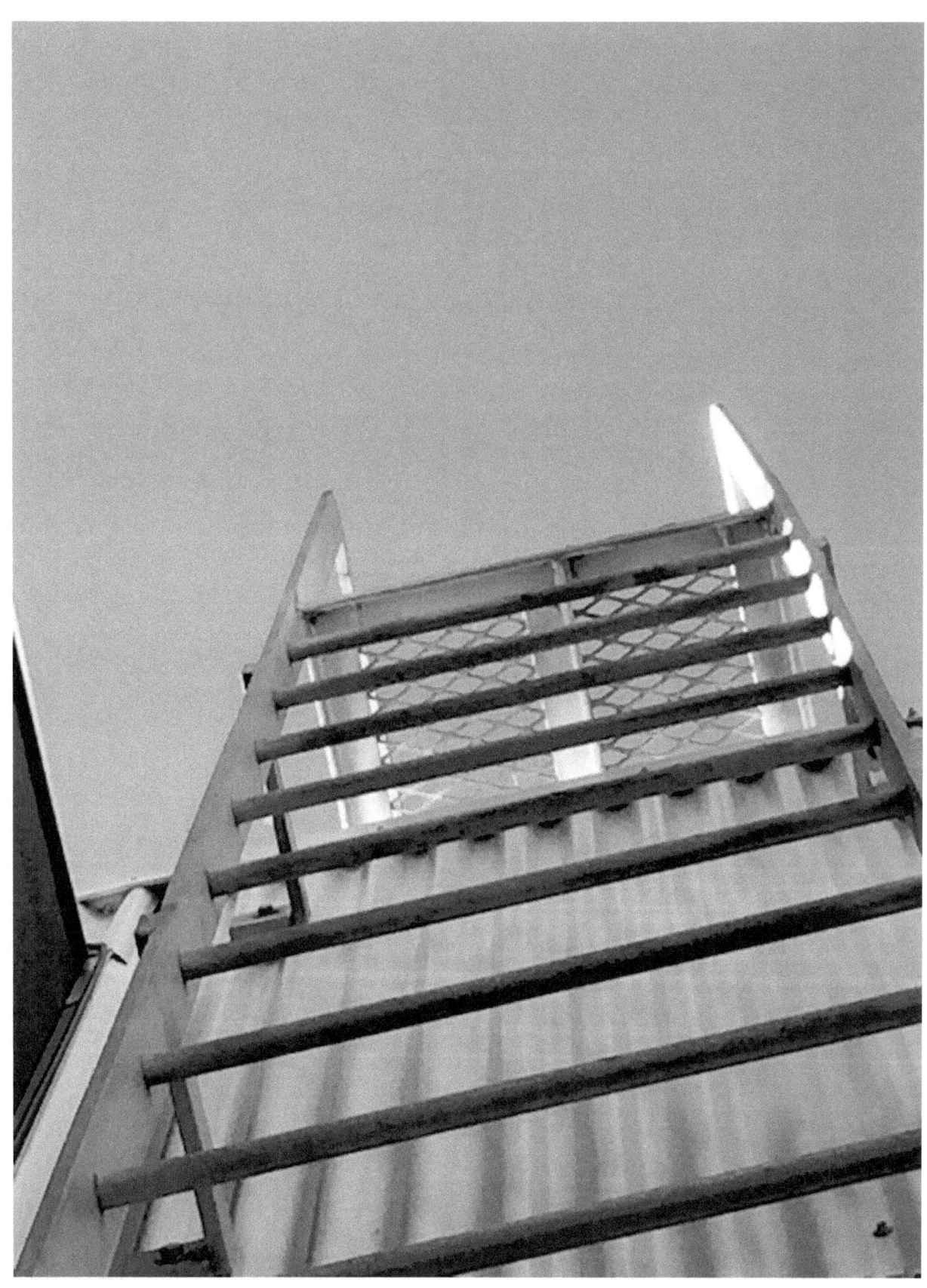

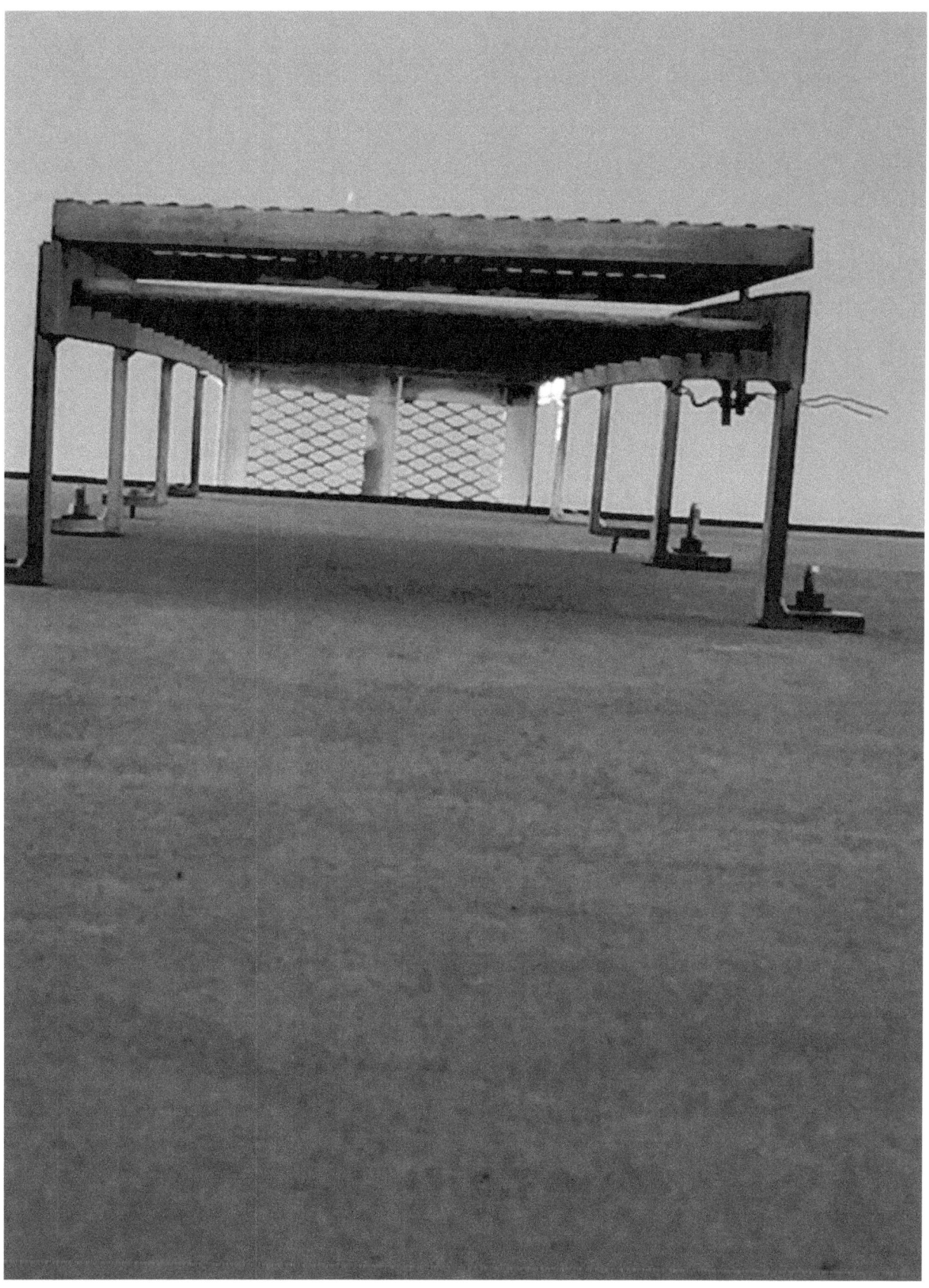

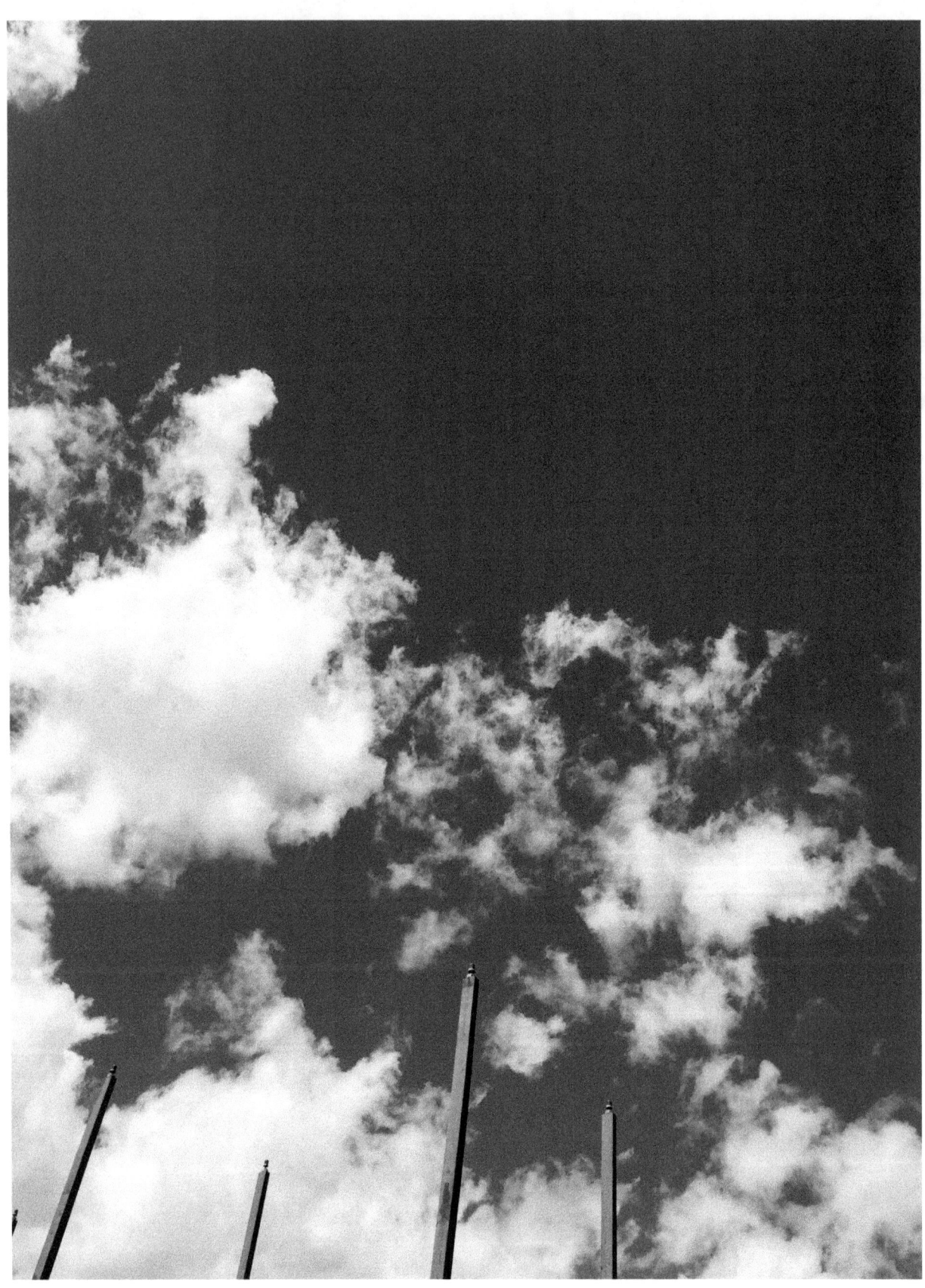

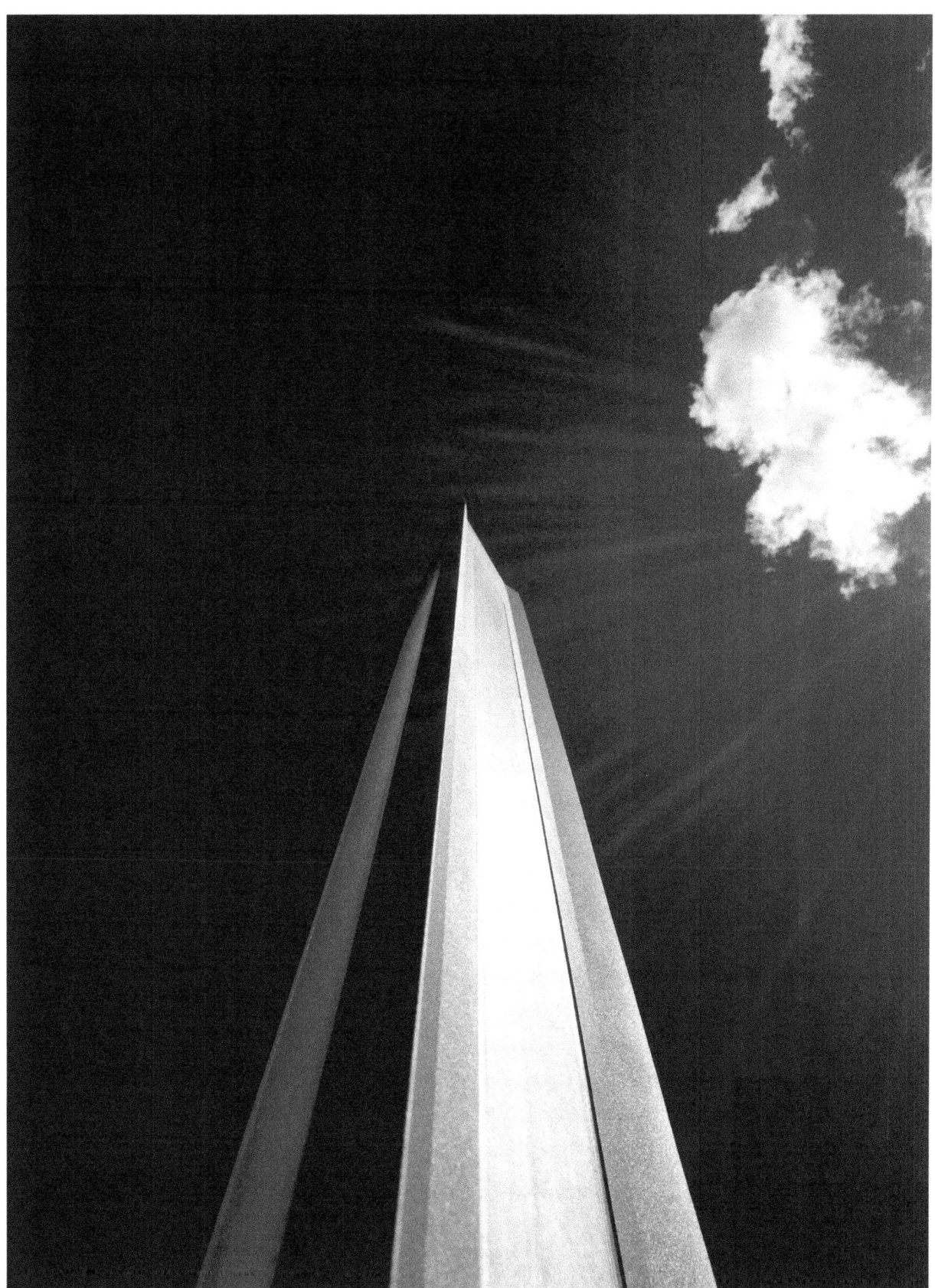

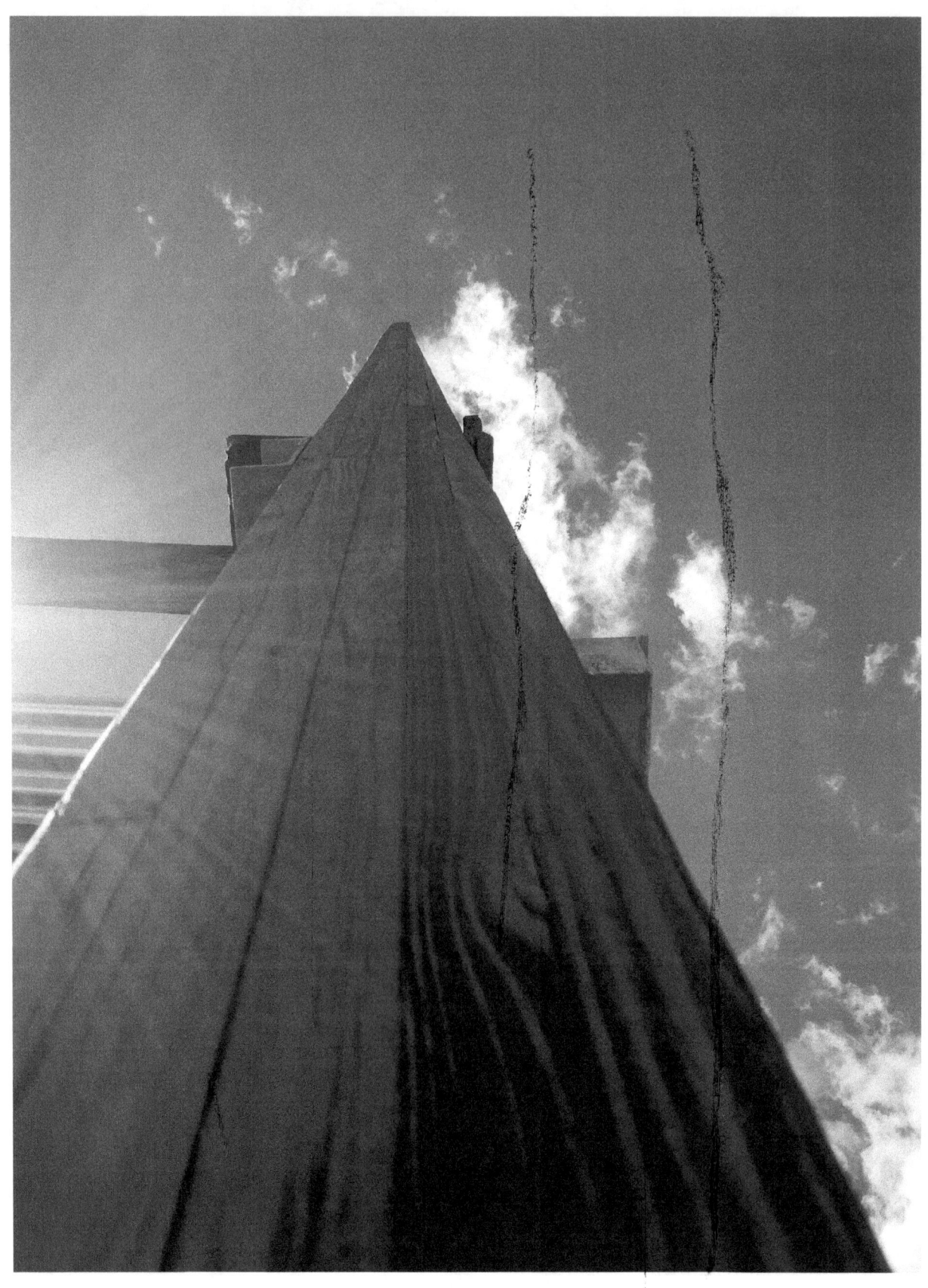

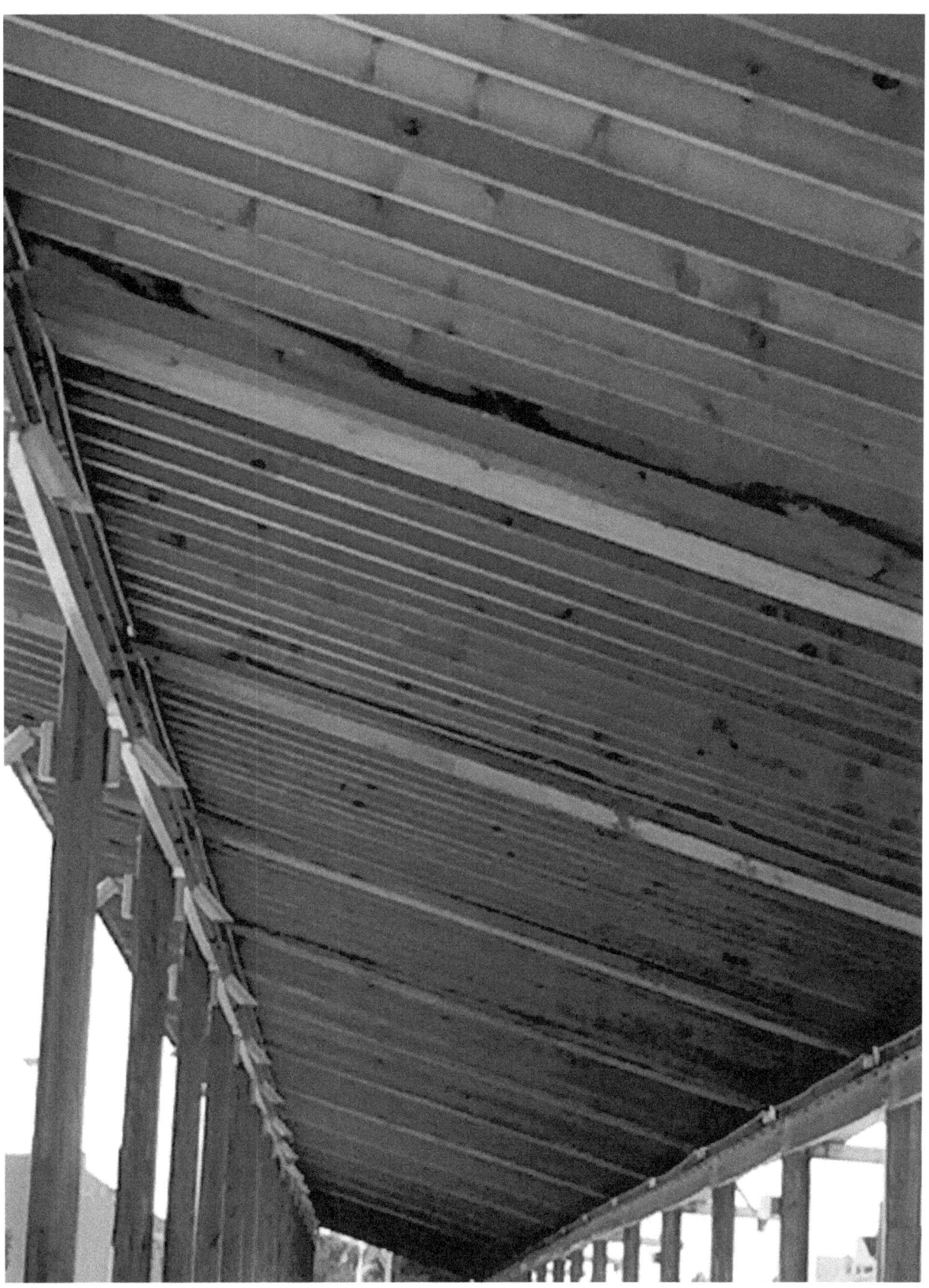

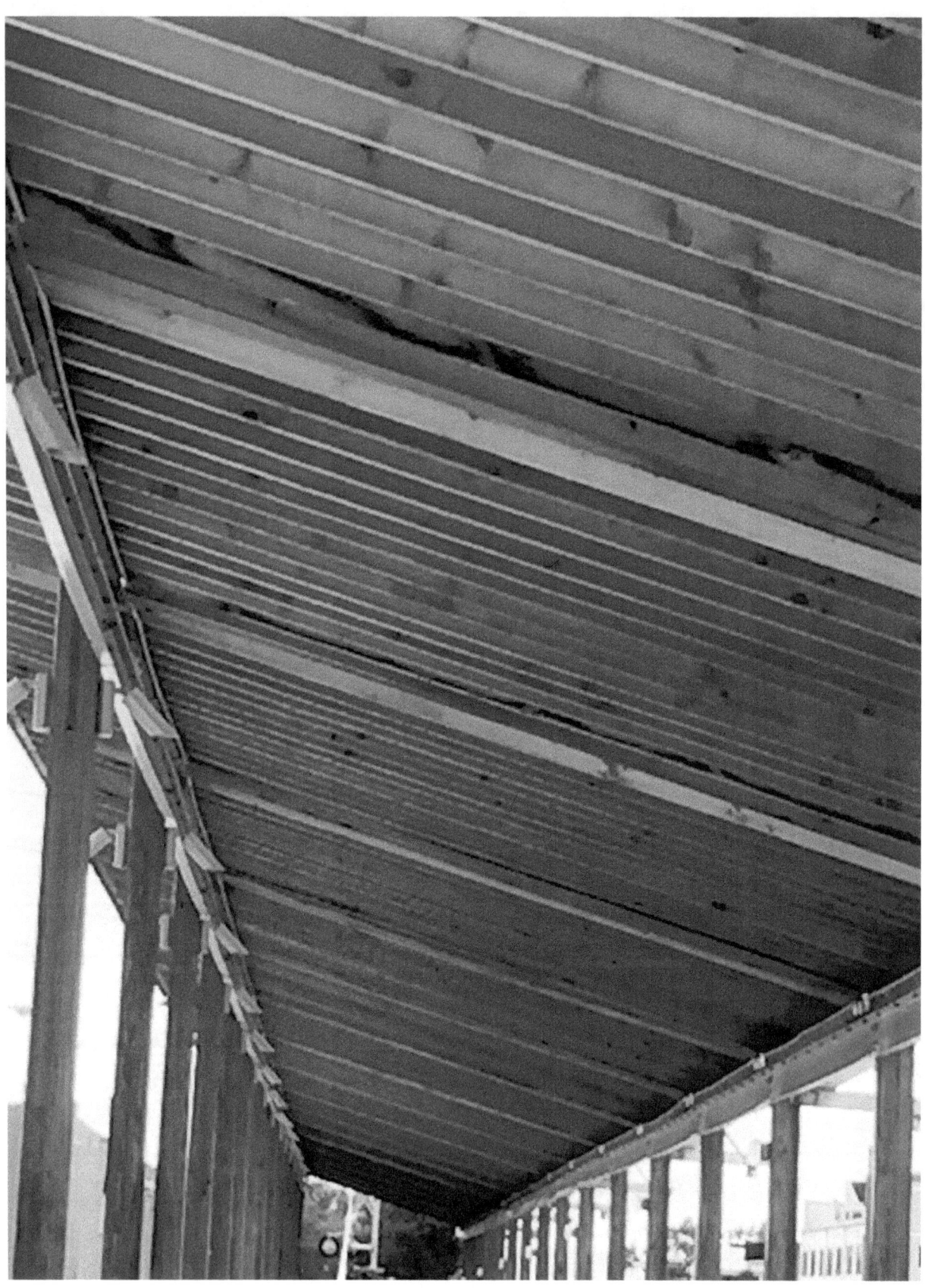

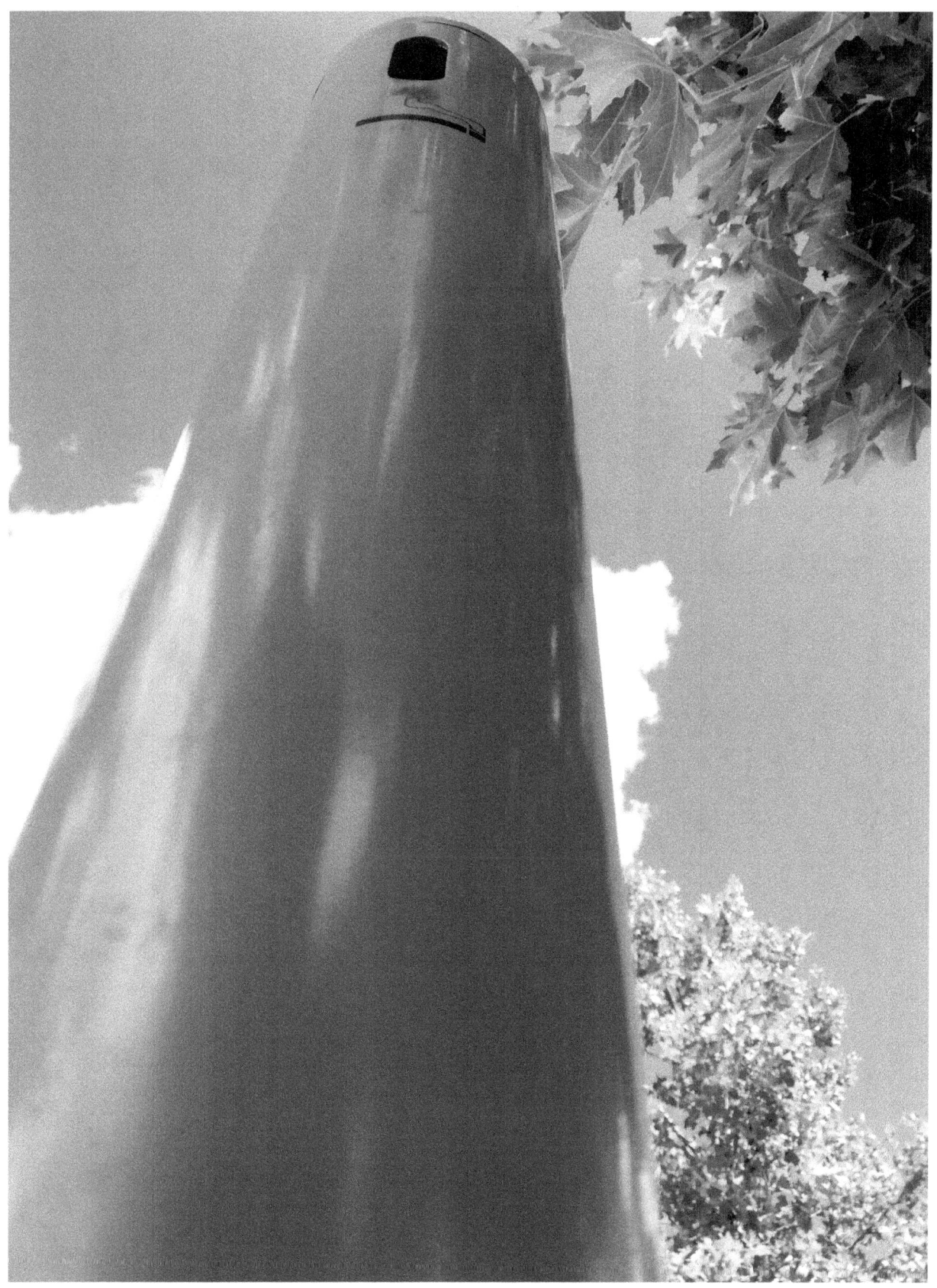

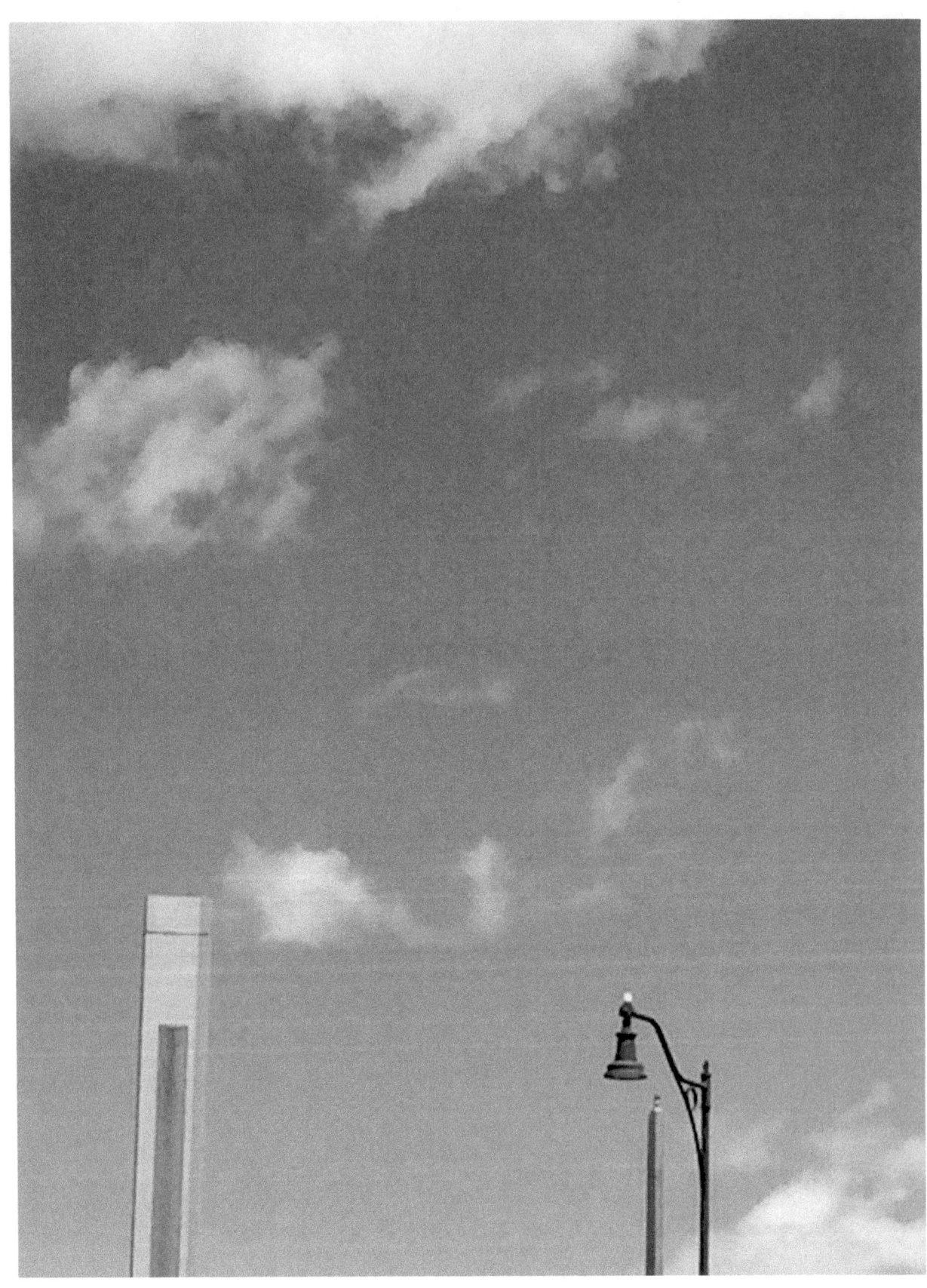

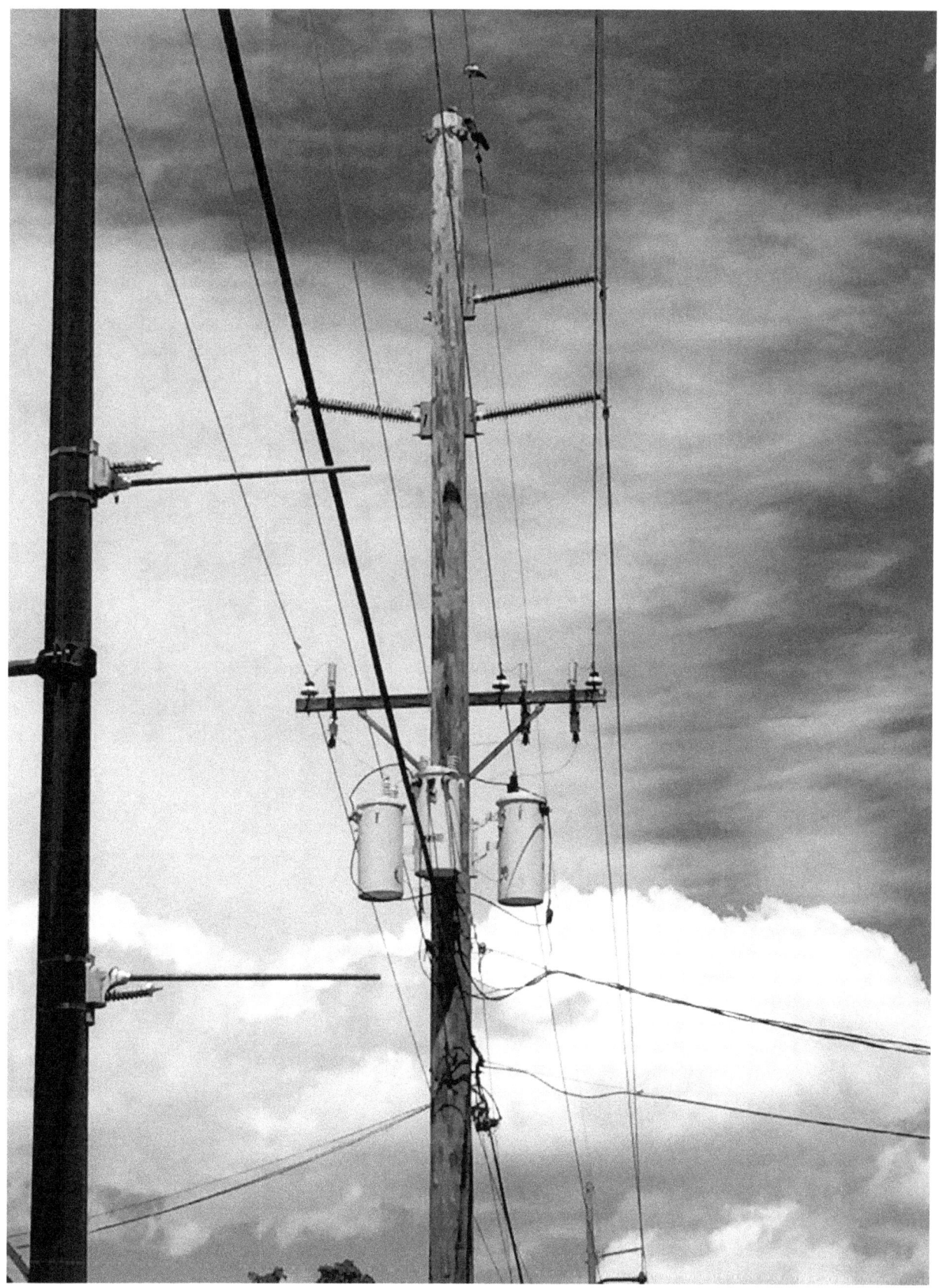

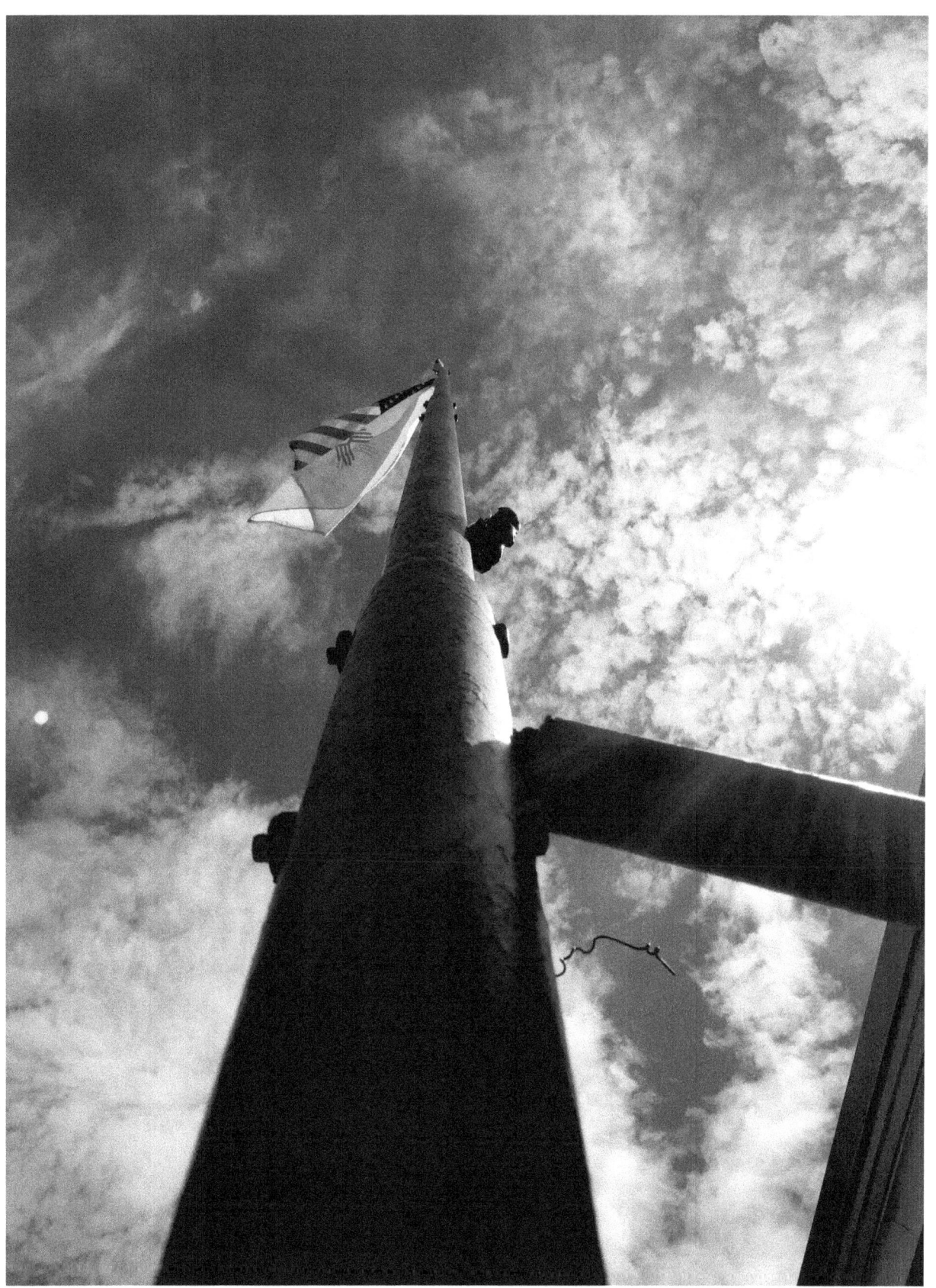

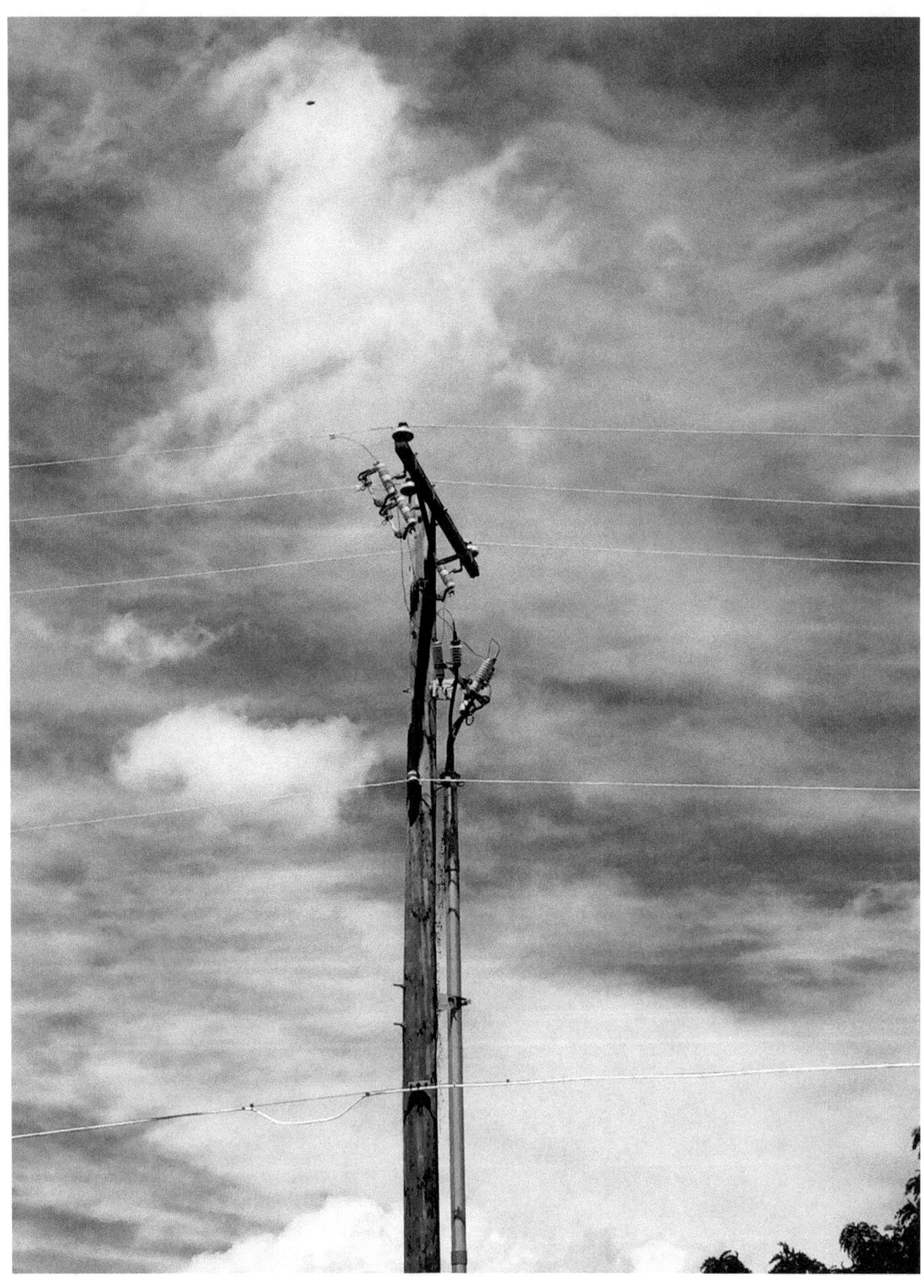

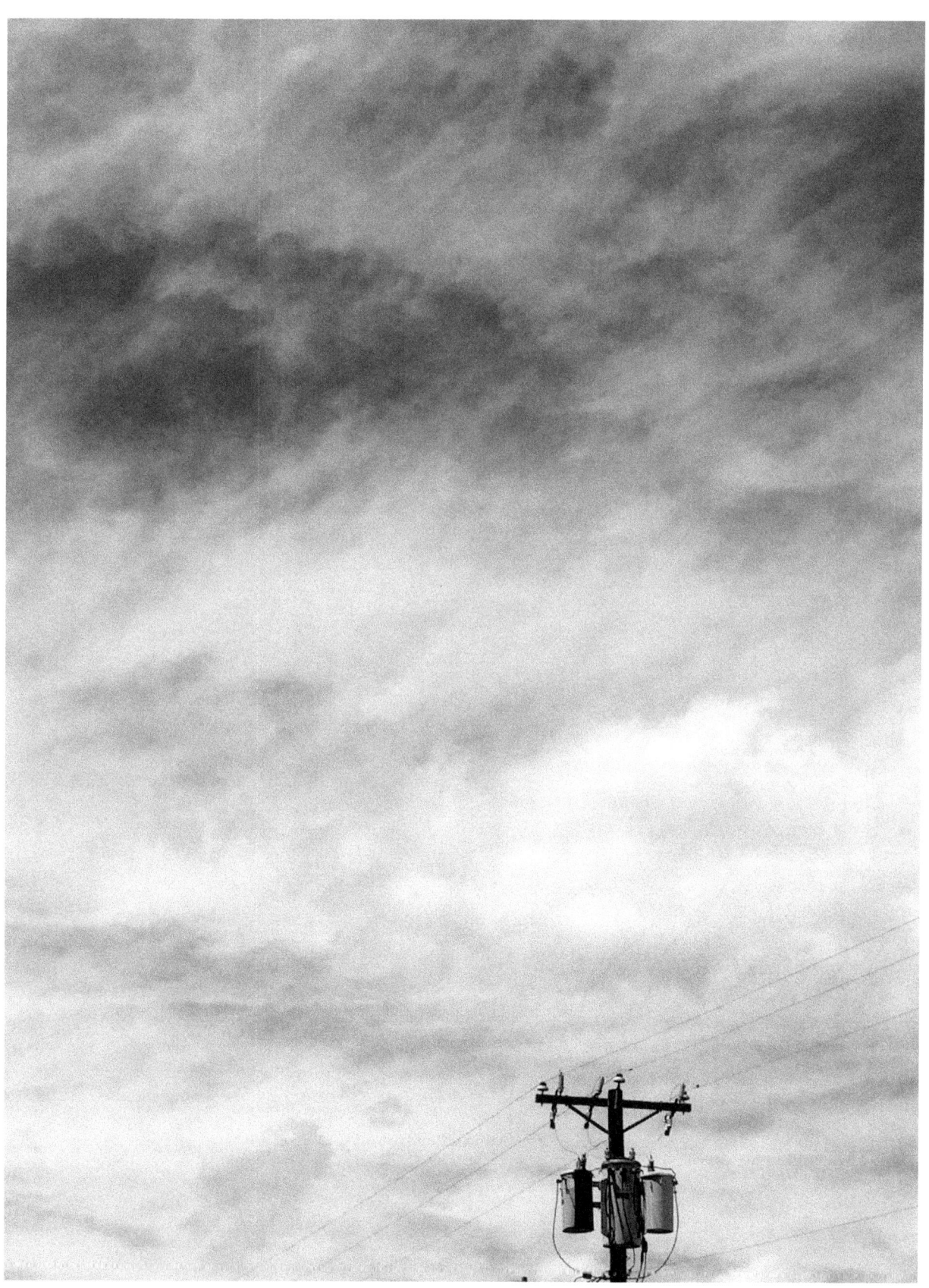

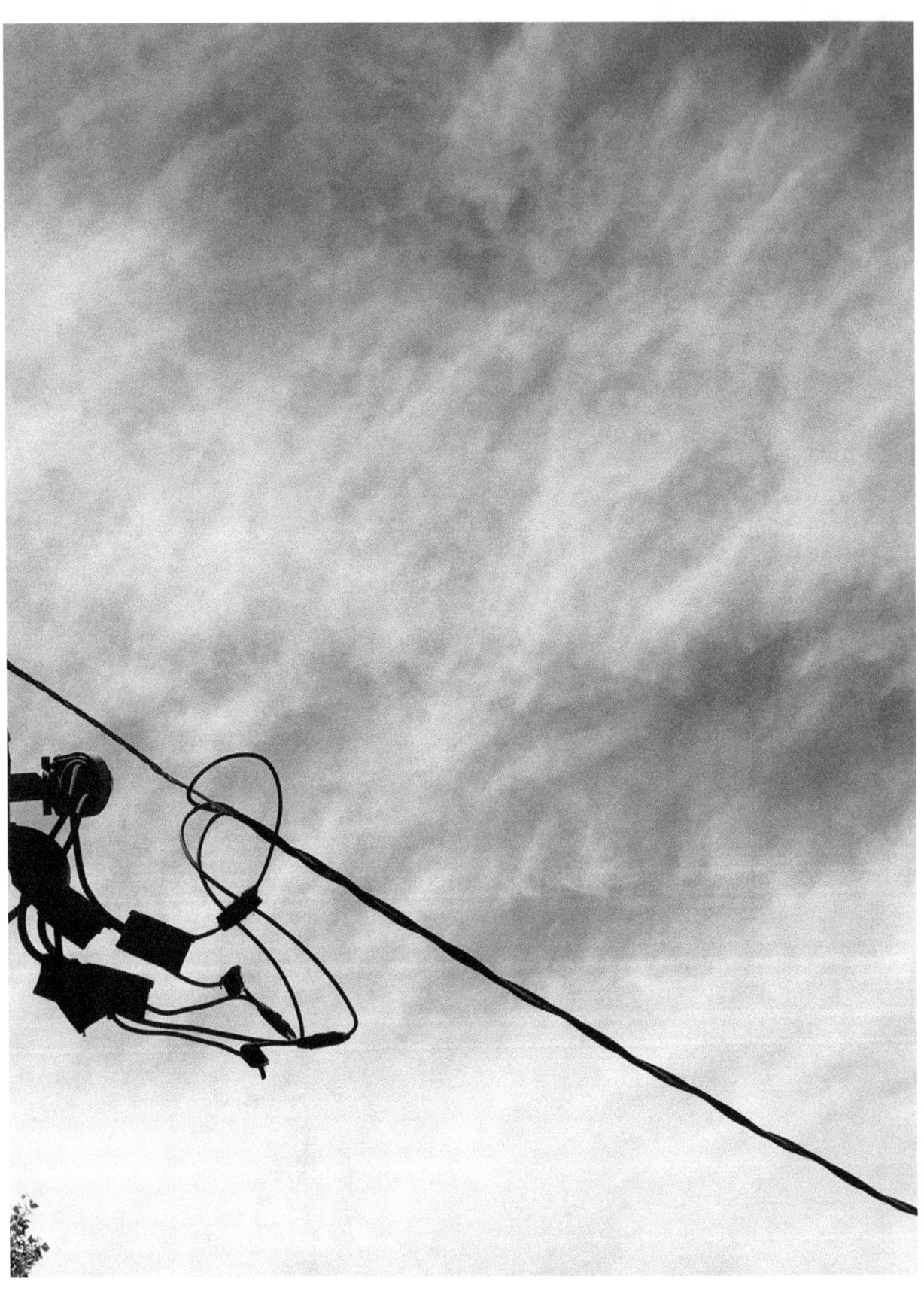

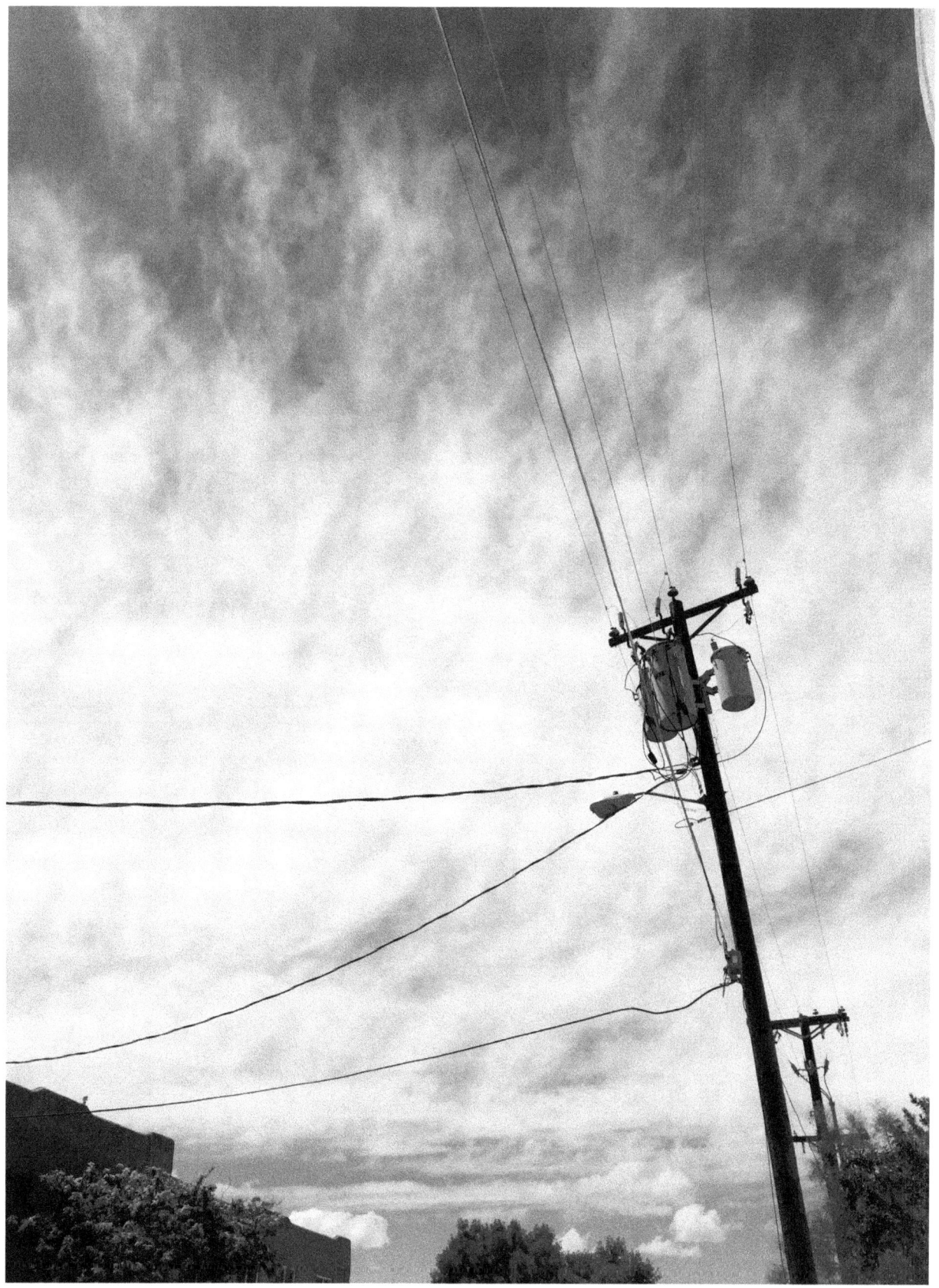

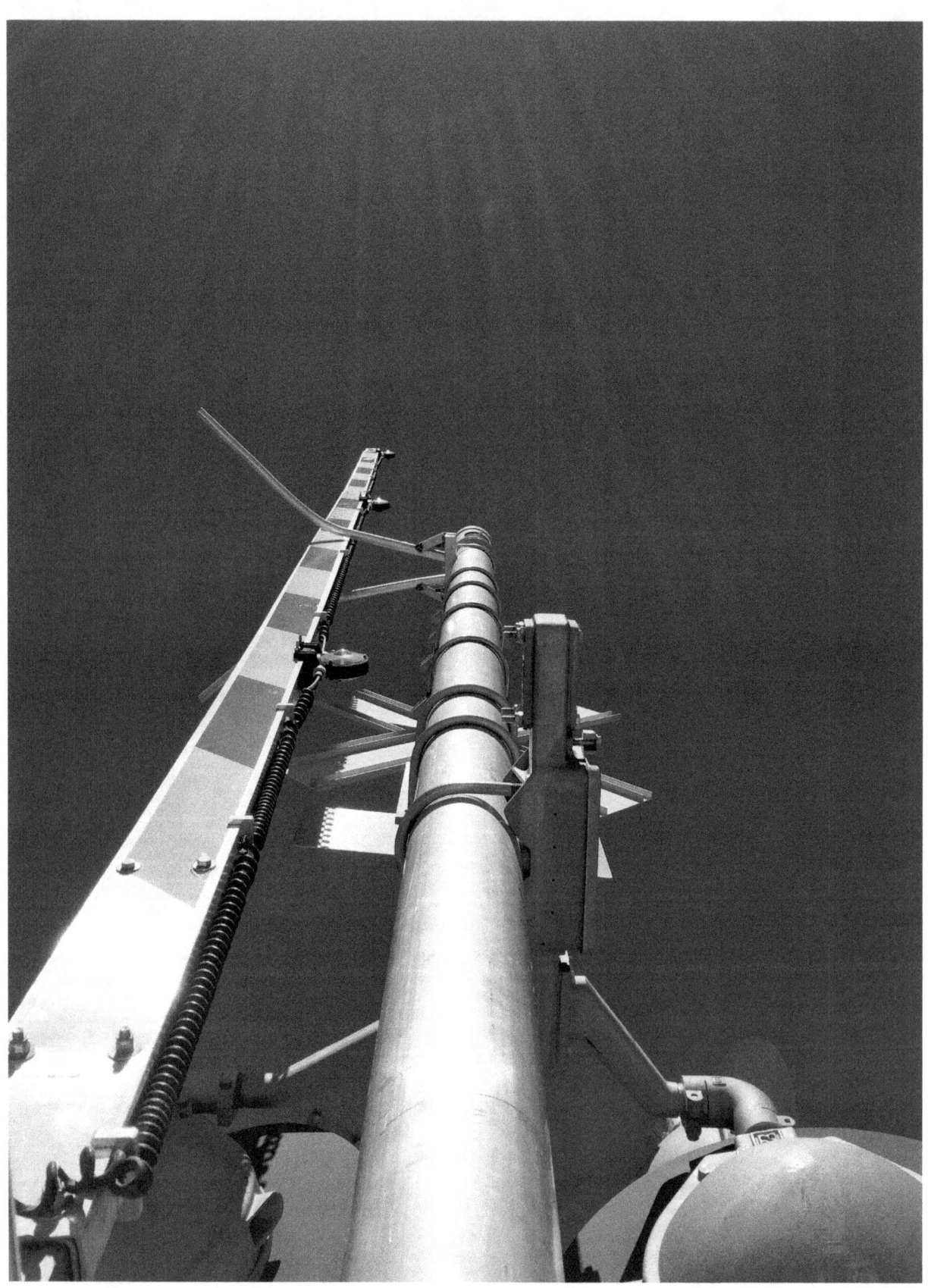

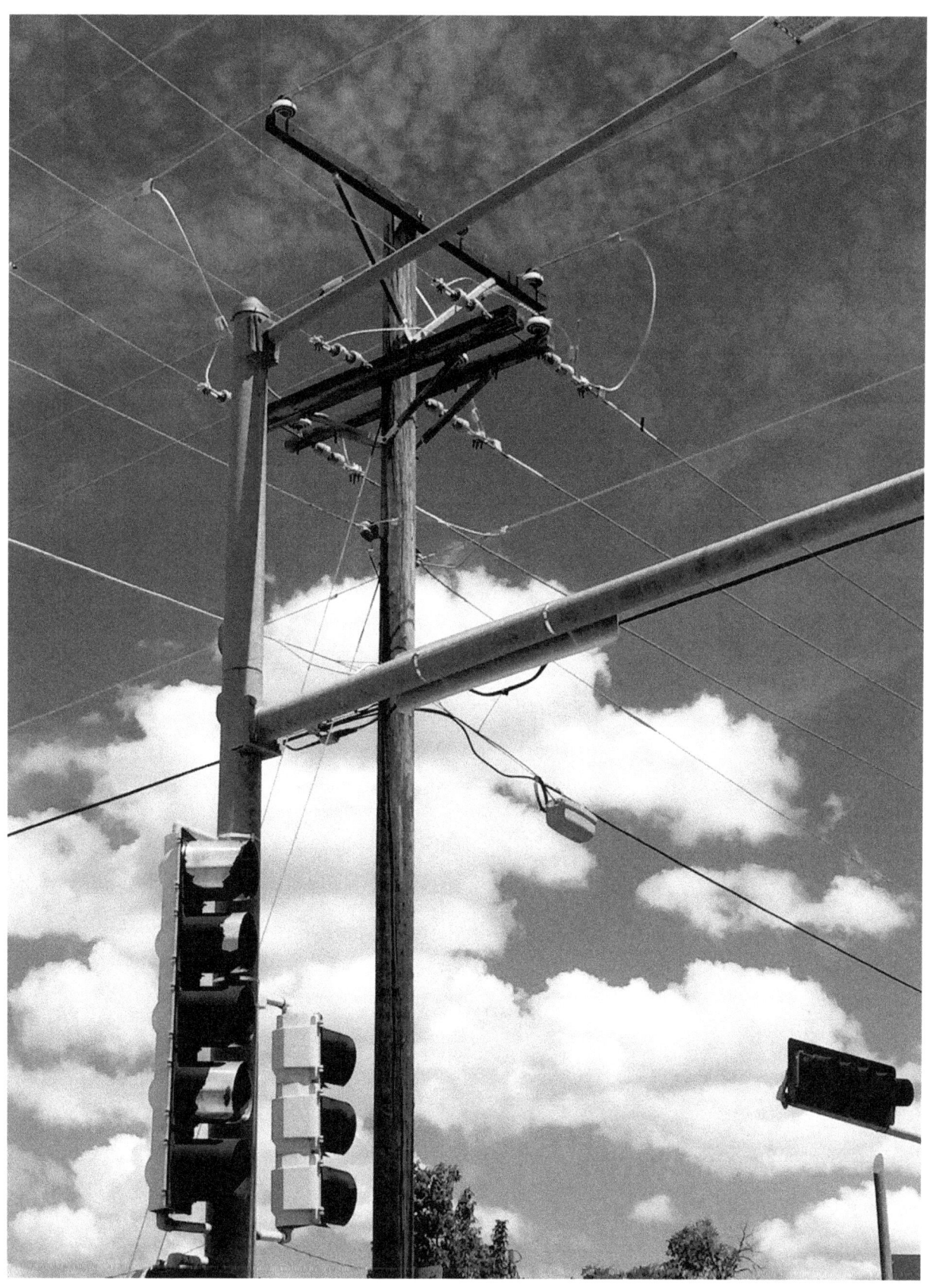

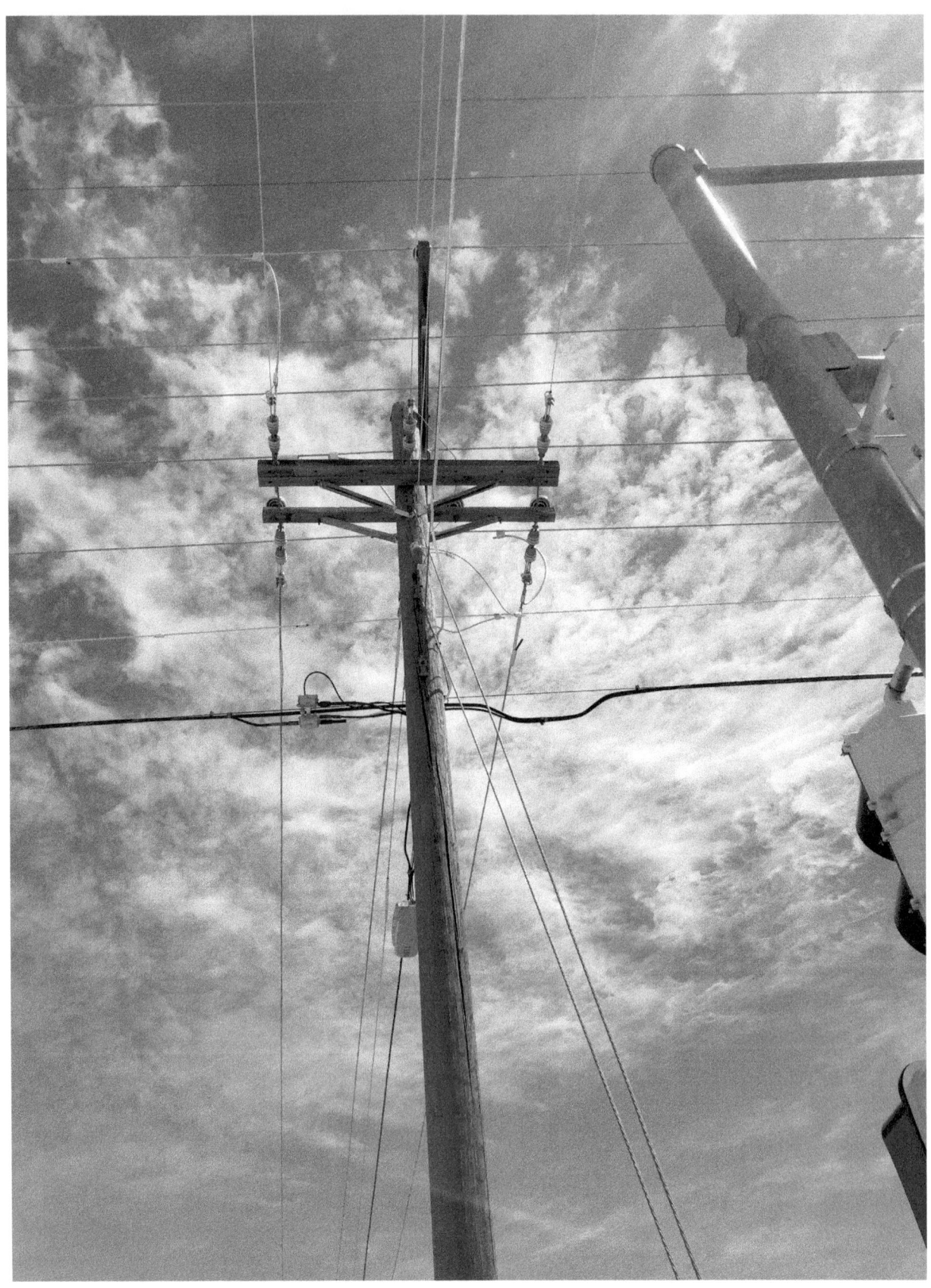

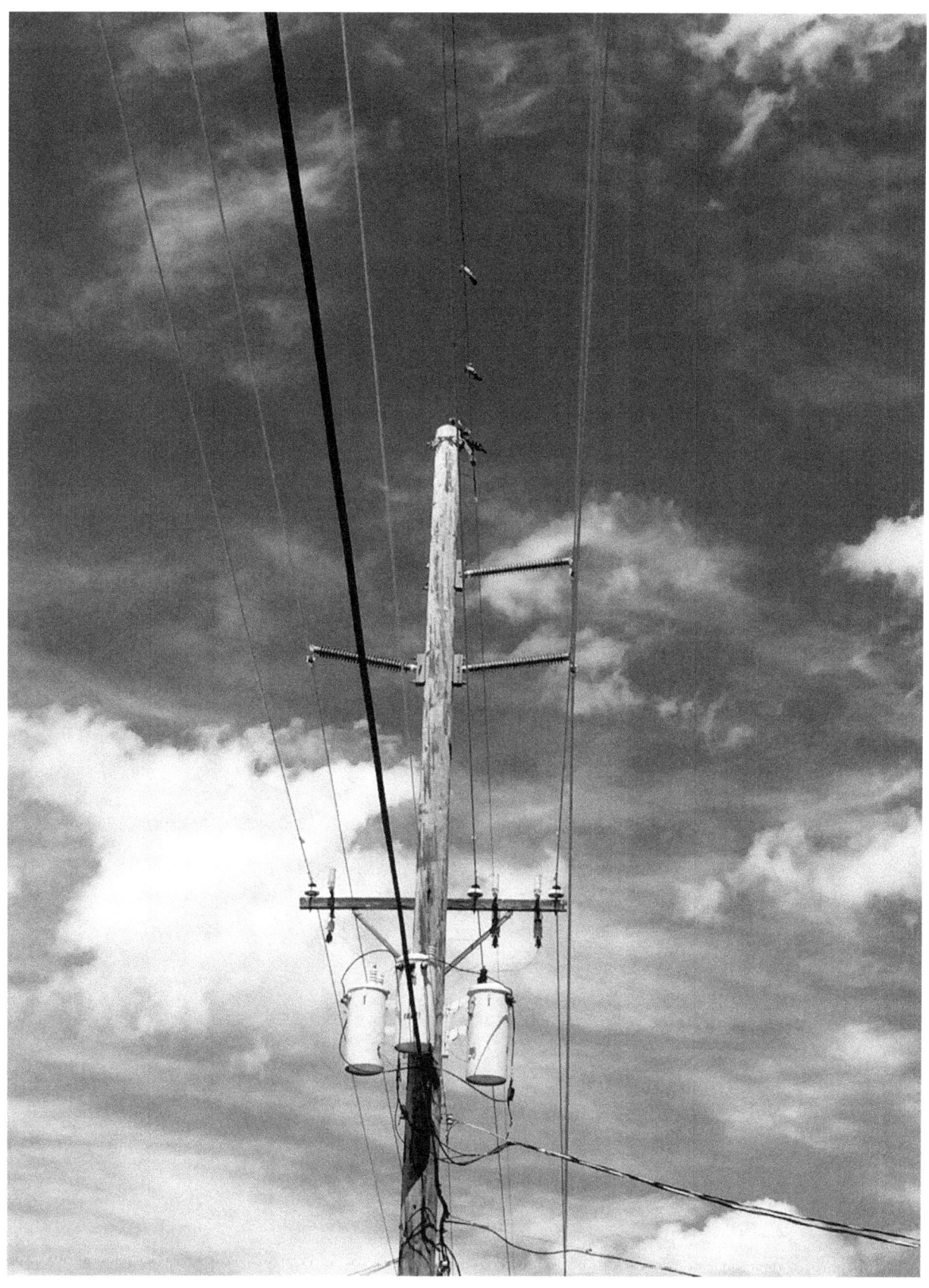

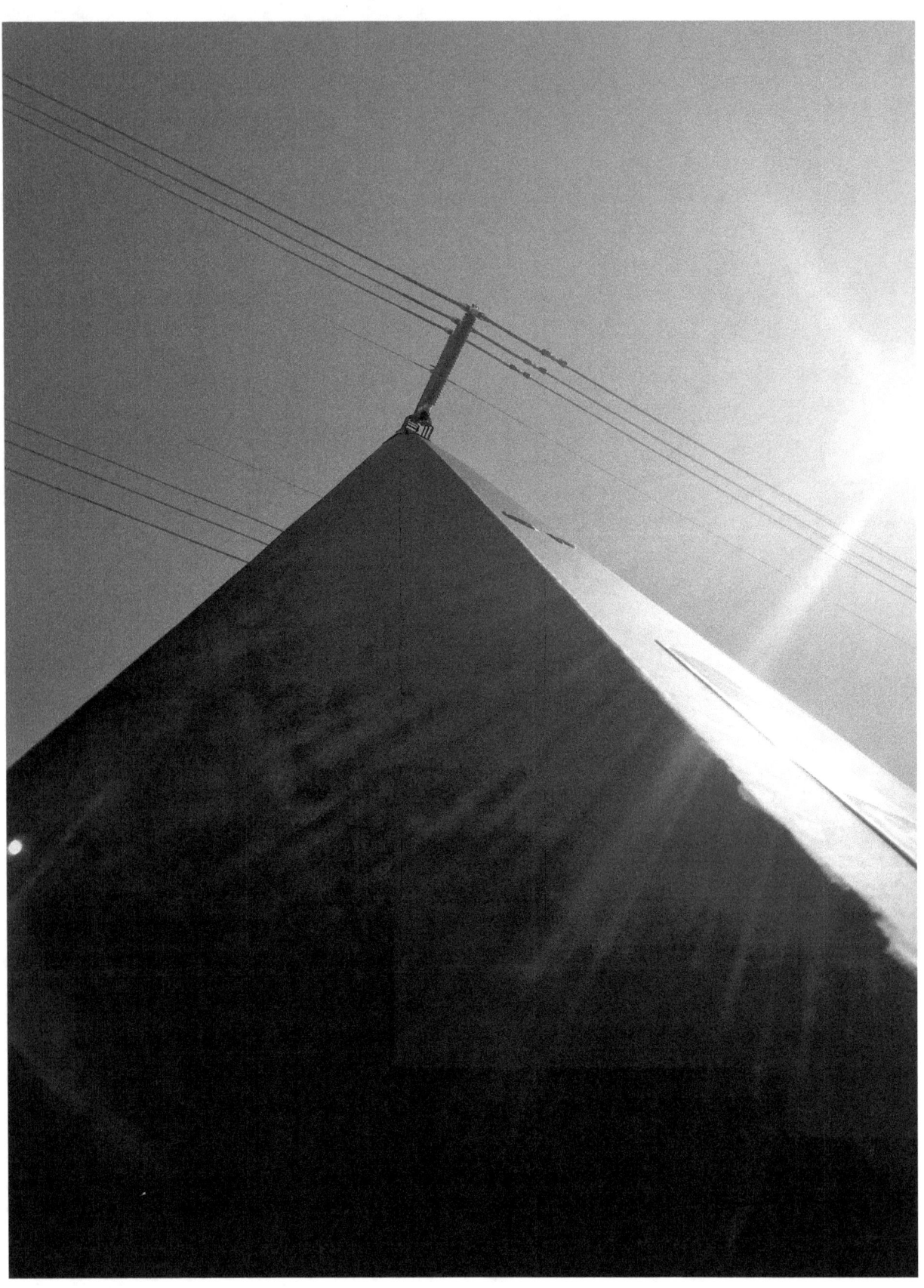

www.ingramcontent.com/pod-product-compliance
Lightning Source LLC
Chambersburg PA
CBHW080559190526
45169CB00007B/2823